GNEISSLINE PUBLISHING TULSA, OKLAHOMA

**Wishing you every happiness
this Holiday Season, and continued
success in the coming year!**

Kirk *Brian*

**Norris & Stevens
503-223-3171**

Pilgrim Eye

DAVID HALPERN

INTERNATIONAL STANDARD BOOK NUMBER 978-0-9788165-0-6

LIBRARY OF CONGRESS CONTROL NUMBER: 2006907160

PAGE ONE: GNEISS AND SCHIST, ROCKY MOUNTAIN NATIONAL PARK, COLORADO, 1985

FRONT COVER: AVALANCHE GORGE SCULPTURE, GLACIER NATIONAL PARK, MONTANA, 1992

GNEISSLINE PUBLISHING BACK COVER: MORNING, BRYCE AMPHITHEATRE, BRYCE CANYON NATIONAL PARK, UTAH, 2004

5819 SOUTH KNOXVILLE AVENUE

TULSA, OKLAHOMA 74135-7841 PRINTED WITH FOUR PROCESS INKS PLUS TWO PANTONE INKS ON 170-GRAM LUMI SILK

(918) 742-8978 TYPESET IN ADOBE WARNOCK PRO AND ADOBE BICKHAM

FAX: (918) 742-8979 PRINTED IN CHINA BY GLOBAL INTERPRINT

DAVID@DAVIDHALPERN.COM

HTTP://DAVIDHALPERN.COM DESIGNED, EDITED, AND PRODUCED BY CAROL HARALSON, SEDONA, ARIZONA

ACKNOWLEDGMENTS

for Sue

AND IN MEMORY OF JUDITH WEINSTEIN HALPERN

The evolution of this book from a collection of black and white landscape photographs to a broader commentary and retrospective is the result not only of many years of photography, but of life changing events and relationships that have helped to define my work and the person I am.

There are many people I would like to thank personally who sadly are gone but live each day in memory. They are the family, friends and mentors who helped me develop sensitivity to my environment and from whom I extracted values that gave meaning and purpose to my life. These include my violin teacher and former concertmaster of the Nashville Symphony Orchestra, Kenneth Rose; my high school art teacher Helene Inge Connell; Jim Lee Allen, who admonished her students to "do a thing because it is right, not because you have to;" artist and friend Kipp Schuessler, who always had time to offer encouragement and became my role model; Maxine Cremer, who gave me my first gallery show; and my father, Nathan Halpern, who gave me most of the values by which I live.

My earliest photographic mentor, Billy Easley, receives deserved mention elsewhere in this book, along with other influences. I also want to acknowledge Dennis Thompson and Bob Hawks, photographers who provided encouragement during my transition from amateur to professional, and Katherine Hawthorn Frame for patiently reviewing my text and offering constructive criticism.

I owe much to my students from the classes and workshops I've taught over the past thirty years. Were it not for their probing questions, I could have taken so much for granted without seeking the reasoned explanations that have helped me better understand our craft.

Thanks to four of my former assistants—Bill Welch, Christopher Weeks, Lynn Endres, and Catherine Peters—for having the courage to push me beyond the limits of my own "box."

To friends in the National Park Service who provided opportunities to live in and explore the places I love best, I owe an immeasurable debt. Though the work in this volume covers a period of more than fifty years, the last thirty-five have produced what I consider my most important statements. Thank you Glenn Kaye, Corky Hays, John Welch, Dave Roberts, Jim Thompson, Susan Hepler, Dave and Martha Thomas, Curt Buchholtz, Larry Frederick, Shirley Beccue, Bob Jacobs, Cindy Nielsen, and especially Bill Sontag, who continues to share his knowledge, insight, and constructive criticism with me after more than three decades.

I gratefully share the credits for this book with Carol Haralson, the gifted designer who brought order out of chaos, with unique style and sensitivity for both pictures and words. This book would not have come to be without her inspiration and guidance.

Throughout their growing-up years, my sons, Alan and Lee, traveled with their mother and me, hiked with me and shared memorable experiences that are

reflected in my images. They allowed me to see through their eyes, hear the sounds of nature as they heard them, and they were patient when I set up my tripod or disappeared under my focusing cloth to compose pictures. Though neither pursues photography for his livelihood, both are now sharing their sensitivity with their children, and I only wish for my grandsons the same gifts their fathers gave me.

Judith Weinstein Halpern was born in Nashville, Tennessee on December 8, 1937 and died a victim of leukemia on September 7, 1996. We were married on June 9, 1958, shortly after my graduation from Vanderbilt University. Through the thirty-eight years we shared, Judy was my constant support, my best friend and confidante. While facing terminal illness, she lived fully to her very last hour of her very last day with courage, grace, and determination to make a difference in her world, and she achieved her goal.

My work on this book began before Judy first received a diagnosis of megaloblastic anemia in 1992. It resumed in earnest in 1998, after Sue Guterman and I were married.

A person who loses a spouse can have many reasons to remarry. However, if the first marriage was successful and valued, then that union should be sustained in memory and its uniqueness celebrated. So it is that Sue and I share a marriage that celebrates the best of what we both have gained through prior relationships and which nurtures the best that both of us are able to give. Her encouragement has led me in new directions, expanding the range of my efforts.

I dedicate this representation of my life's work in Judy's memory and to Sue, to whom I will be forever grateful.

~ DAVID HALPERN, 2006

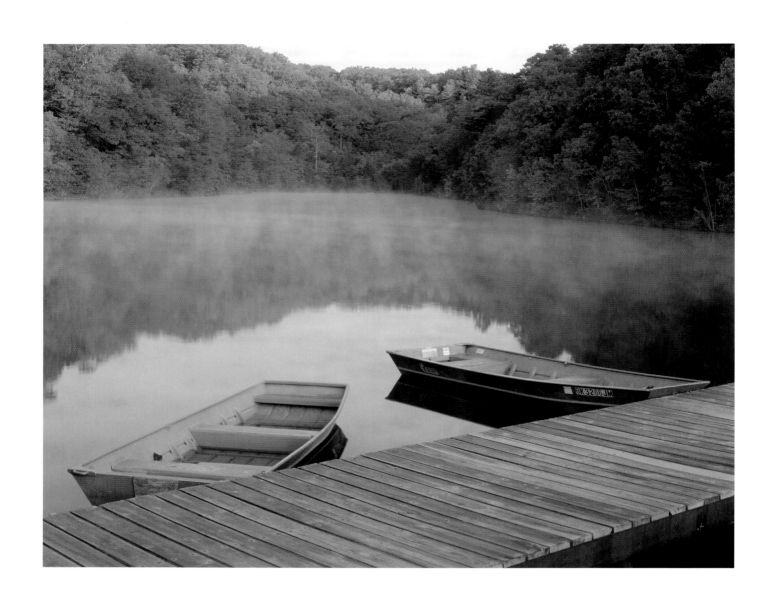

EARLY MORNING, EASTERN OKLAHOMA, 1991

BY BILL SONTAG

Taught by the Mirror

YOU WILL NEVER LOVE ART, 'TILL YOU LOVE WHAT SHE MIRRORS BETTER.

JOHN RUSKIN, EAGLES NEST LECTURE III, 1872

"Bill, there's a guy up here at the front desk that wants to talk to you . . . he looks like Moses, but I think he makes pictures."

The whispered intercom message, from a co-worker I remember only as "Jessie," caught my attention. And indeed, meeting David Halpern that morning at the Wichita Mountains Wildlife Refuge brought to mind the old cliché "You're not from around these parts, are you?"

It was not so long ago, but it was before cell phones, pagers, Windows®-based computers, Palm® Pilots, and the BlackBerry®. It was before answering machines and microwave ovens were standard in nearly every home. And it was before digital photography was available to any but government agencies and the very wealthy.

Halpern carried more weight then and had much longer hair, artfully arranged by Oklahoma winds. His presence was riveting, but his eyes were gentle. Everything I saw as we shook hands seemed rugged but refined, educated.

In the early 1970s, I guided public use of the 59,000-acre National Wildlife Refuge in southwest Oklahoma, and David (he quickly discouraged me from addressing him as "Mr. Halpern") wanted to be guided to its most photogenic, secret places.

As with any provocative new acquaintance, Halpern was a teacher from the start, however informal. In our immediate, if unspoken, quid pro quo, I showed him places I thought important to capture on film, and he shared his "seeing" with me. It was the initiation of a thirty-year friendship, one among many Halpern has sustained through a career marked by pilgrimages to America's crown jewel landscapes and shrines.

Halpern's stunning photographs—both in color and in black and white—reveal abiding reverence for his subjects, the care he takes in making a record of them, and sometimes his appreciation for the absurd and the humor he sees in the oddest places.

In the same year that Ruskin offered his stern admonitions and aphorisms to British art students, on this side of "The Big Pond" President Ulysses S. Grant signed into existence the world's first national park, unwittingly ensuring the future inspiration of artists—now numbering thousands—who would gravitate to the national parks.

In 1871, the Yellowstone country's marvels of scenery, geothermal basins, cascading rivers, and abundant wildlife were captured in Thomas Moran's small watercolor paintings and field sketches, as well as in the equally unpretentious black and white photographs of William Henry Jackson. But Moran and Jackson clearly were not satisfied with mere documentation. They transformed nature into art. Moran's later gargantuan paintings and Jackson's large-format contact prints reveal eyes seeing as succeeding generations of artists would see.

David Halpern is part of this tradition.

Halpern has been both classroom instructor and university professor, but his greater impact may arguably be among those he has taught the least formally. While skilled at didactic methods, Halpern shines brightest in the canyons, valleys, meadows, mountains, and riparian spectacles that inspire art. Hands-on use of increasingly sophisticated equipment, surrounded by landscapes that change but little, once preserved, offer opportunities for teaching that Halpern cannot resist.

Though one might see in this retrospective the steady growth, change, and maturation of Halpern's photographic skills and interests, generalizations about his "students" would be folly. In 1975, I watched Halpern standing with a small group of tourists on the crown of a Civilian Conservation Corps dam in the Wichita Mountains. He waved his arms at a developing sunset as his photographically curious, socially diverse audience stared across the lake's deep and darkening waters, holding cameras that ranged from a handed-down Kodak box camera to a spiffy new Leica 35mm with a long lens. All were anxious to capture the moment with tips from their enthusiastic tutor. As artist-in-residence in Rocky Mountain National Park, Halpern offered far more technical advice to workshops of serious students consummating their own pilgrimages to one of the most photographed, sprawling landscapes in the nation. While Halpern may be the central common bond between such disparate groups, they also share another connection: the *ah-hah!* moment that occurs when something clicks, uniting their equipment—regardless of sophistication—with new skills and techniques, new ways of seeing. One of Halpern's gifts is the ability to inspire this moment, whether he is teaching formally or casually, to amateurs or aspiring professionals.

A story is told about pioneering art photographer Edward Weston (1886–1958) and his equally brilliant son, Brett (1911–1993), working with their respective

cameras near Carmel, California, around 1930. As the younger Weston struggled with composition of the subject, his grumbling finally got his father's attention. Edward looked, abruptly turned the camera into a vertical format position, and walked away without comment. To Brett's astonishment, the perfect image was there, seen instantly by his teacher and mentor.

Halpern's approach is more suggestive and cautious than that of the notoriously gruff, often cranky Edward Weston, but the revelations he inspires may be as dramatic for many of today's students.

"Have you thought about cropping this a little tighter, starting from here?" "What would happen if you dodged here a bit, and burned there just a little?" "What does this corner over here have to do with what you're trying to show?" All are comments I've been able to wheedle out of Halpern on rare occasions, and all have made me frown first, and then—*ah-hah!*

Teaching is not limited to classrooms, with or without walls. Halpern has contributed to the intellectual development of National Park Service employees and park visitors with both photographs and with resources donated for the purpose. He dedicated a portion of proceeds from sales of his portfolio of large-format images of six national parks, each bearing the imprimatur of the seventy-fifth anniversary of the National Park Service, to the Horace Albright Employee Development Fund and the Ansel Hall Fund for National Park Interpretation and Educational Programs. His exhibition of large-format prints, *By a Clearer Light,* traveled the country to help celebrate the 1916 creation of the National Park Service.

Halpern has a robust and determined sense of humor. In the 1970s he poked fun at himself and his ever-present, face-filling camera by applying for a personalized Oklahoma license plate (inexplicably twice denied) announcing the

driver as CYCLOPS. And while his images remain largely apolitical, his writings—letters, essays, commentaries—are filled with thought-provoking prose that infuses the photographs with deeper significance.

But, as with any art worth its salt, Halpern's images speak for themselves. *Thor's Hammer at Moonrise* (page 92) reveals textures and contrasts that even on-site visitors might miss, simply because the black and white refocuses the viewer's attention to detail, trumping the now-traditional super-saturated colors expected from Utah landscape artists. Halpern's venture to Bryce Canyon as artist-in-residence was a bold affirmation of his belief in the historic medium of black and white film, chemicals and rich papers. Though some saw the effort as atavistic stubbornness in canyon country long-obsessed with color, *Thor's Hammer* remained a popular poster in the Bryce visitor center for many years.

In Golden Canyon (page 53) might surprise visitors to Death Valley National Park who stop at the popular wayside during "flat light" hours of the day. Its golden reputation is earned during crepuscular minutes, or when a passing cloud simultaneously shades and accents the colors. The gold, seen here by Halpern in glints of reflected and re-reflected light, frames muted tones of color-banded strata.

Halpern's versatility, already proclaimed by his transitions from often-voluptuous commercial art to western landscapes to Tulsa's timeless Art Deco, is corroborated by the subtle colors and lines of images such as *Misty Morning, Eastern Oklahoma* (page 10). From the dock that anchors both the photograph and the shallow-bottom boats—with their mute invitation to explore the tranquil surface—the image is an invitation to the far shores. You can almost smell the fall colors and taste the mist.

While the photographs stand alone as statements of art to be found in nature and aesthetically executed shrines, they inform their viewers only if people

15

peer deeper into Ruskin's "mirror." The images reflect places we may never visit long enough to love for their intrinsic merit. But the mirrors in which we see the images are the architecture of David Halpern's soul, ensuring that we enjoy eloquent glimpses of the national treasures that have informed and impassioned his life and our heritage.

BILL SONTAG, a retired national park superintendent, is a journalist, photographer and freelance writer living in small, but historic Del Rio, Texas. He and his wife, Debbie, are comfortably distant from big cities, yet only a river's width from Old Mexico.

Pilgrim Eye

EARLY PERSPECTIVES AND TRANSITIONS

MY EARLIEST RECOLLECTIONS of photographic experiences are associated more with odors and feelings than with images. Sensory experiences can be powerful stimulants to memory, and I still recall the scents and textures of materials no longer common in the tools we use today. The smells of my first darkroom were distinctive to the chemicals, films and papers of that time.

My parents' Kodak box camera had a metal film carrier, but the body was made of cardboard with black leatherette glued to it. It had a metal film winder, shutter release and decorative trim. These materials combined to impart an aroma so unique that it stands out still in my memory, though I struggle to find words to describe it accurately.

I vividly remember the odors of my first darkroom. I enjoyed the musty-sweet scents of developing agents the names of which have faded into history. My favorite for several years was called 777 Panthermic, although I mixed many other solutions using Kodak, Ansco and DuPont formulae. I easily came to tolerate the more pungent fixers and the acetic acid stop baths wafting from porcelain trays and hard rubber tanks. Films and papers also had distinctive aromas, and for a time I could even distinguish between different brands by their scents.

Remembering these smells takes me back to the late 1940s when I first developed orthochromatic[1] black and white film under a dim red safelight. I worked in a makeshift darkroom set up in a corner of my parents' attic.

My first contact with a camera was my parents' Kodak box Brownie. My uncle Henry Meyer had a more sophisticated pre-World War II Argus C3 which I thought of as "a real camera" and secretly lusted after.[2] I settled, however, for a variety of simpler tools, including the Brownie Flash 620 I used to earn the dollars that paid for my first "real" camera, a Century Graphic purchased around 1951. That was when I became serious about making photographs.

At the turn of the twentieth century George Eastman had popularized roll film and the box camera and was hailed for making photography available to virtually everyone. So by the time of my rather crude introduction to the craft, Eastman's contributions were taken for granted. Photography was playing a major role in our lives, already having broadened our perceptions of the world and become a part of the interpretation of daily news events.

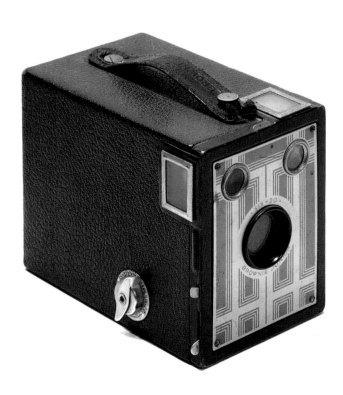
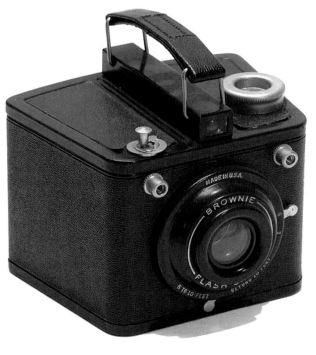

THE KODAK BROWNIE, LEFT, THE BOX CAMERA MY PARENTS USED DURING MY CHILDHOOD. AT RIGHT, THE KODAK BROWNIE FLASH 620. I USED IT TO EARN MONEY TO BUY MY FIRST "REAL" CAMERA.

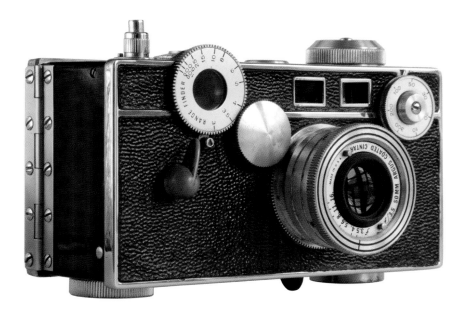

As a child fascinated by the magic of the camera and darkroom, I could not have imagined the enormity of the technological revolution we would experience over the next half century. Nor would it have occurred to me that I would find myself more stimulated by photographic possibilities after I reached what we commonly regard as retirement age than I had ever been before.

In 1936, the year I was born, Kodak introduced its iconic Kodachrome film, and Exacta introduced the now ubiquitous thirty-five-millimeter single lens reflex camera. About the time I learned to develop film, the Hasselblad medium format camera was introduced. The first practical electronic flash units became available when I was a high school student. I remember the introduction of high-speed panchromatic black and white films,[3] the introduction of Ektachrome color transparency film and Kodacolor color negative[4] film. Edwin Land's invention of Polaroid photography and the subsequent introduction of Polaroid sheet films were arguably the most significant technological changes to occur during my years as a working professional, because they enabled us to test our exposures and within minutes to know with certainty that our more permanent conventional films would be properly exposed, even before they were developed and printed.

22

Ansel Adams and Fred Archer made the most important contribution to my photographic technique through their development of the Zone System, a precise method for visualizing the final image prior to exposure and determining the optimum exposure and development required to assure that the printed image would match the visualization.

And now, we are in the digital age, using cameras that capture images by converting light into electrons that record the image on sensors, or semiconductors. The image data is saved to a computer's hard drive, disk or compact flash card instead of film. With digital photography, we create high resolution images that are "developed" with computer software that enables us to do all that we did in the darkroom and much more. We print these images by a variety of methods, obtaining high-quality results on chemically processed media or inks on paper, some of which are capable of achieving image life expectancy in excess of 100 years.[5]

The prospects for the future are exciting. While I respect the tools and methods that were developed in the past and continue to serve photographers well, I have growing faith in the scientists, engineers, craftsmen and programmers who are working to improve the tools and media that will serve future generations. Many of my contemporaries worry about the permanence of digital images and the safety of storage media for digital files, and they are correct to show concern. But I would remind them that film-based photography overcame similar concerns in earlier times when much less scientific knowledge was available. I expect the issues of image stability and file archiving to be resolved in short order. Meanwhile, I will employ caution and vigilance and I will move forward.

My first photographs were not landscapes. They were pictures of people and "things" found in my environment. I became interested in landscapes in 1952, when our family took a twenty-five-day driving tour from our home in Nashville, Tennessee, to the West Coast and back. That was the first time I kept a journal—which I would continue to do from that time on—and in it I recorded seeing my first snow-capped mountains, traveling through Yellowstone National Park and the Grand Tetons, Idaho, Utah, and Nevada, the redwood forests of California, Arizona and the Grand Canyon. I made black and white pictures with my Century Graphic

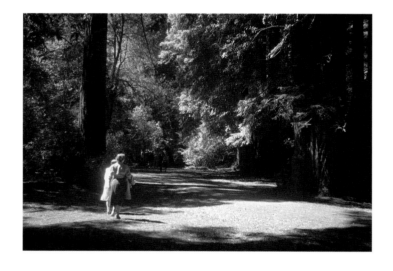

MUIR WOODS, CALIFORNIA, 1952
THE WOMAN IN THE FOREGROUND IS
MY MOTHER.

and exposed 2000 feet of 8mm motion picture film. What subsequently happened to those images had a profound effect on my career.

I was a high school student in 1952, and in the fall of that year I began an art course taught by a wonderfully nurturing teacher, Helene Connell.[6] Mrs. Connell encouraged several students who went on to successful careers and critical acclaim. When Mrs. Connell asked me to share my edited motion picture film with her classes, I was delighted. I spent all of one day showing the film and was asked to leave it overnight so that it could be shown to another group of students the following morning. I complied, and late that evening the school building was totally destroyed by fire. The shock of losing the school was traumatic for all my fellow students, but my loss was personal. I promised myself that someday I would return to all the places I had filmed and recreate those images.

Most of my black and white still images from that journey suffered a similar fate three years later, after I left Nashville to attend the University of Missouri

OLD FAITHFUL GEYSER, YELLOWSTONE NATIONAL PARK, 1972

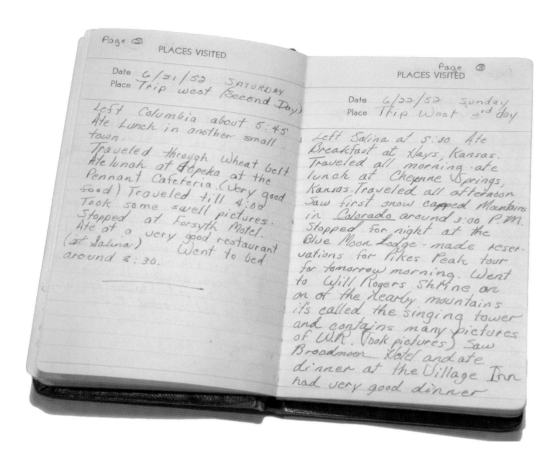

at Columbia. My mother, who was an irrepressible housekeeper, decided to go through my room and discard accumulated possessions that she perceived to have little or no value. Among other things long forgotten, she threw out almost all of my black and white negatives, which to her seemed useless once you had a print. For years she had done that with the negatives of family pictures, and my negatives were surely no more necessary than those. The few images and negatives that survived this cleansing exist today only because I kept them stored in books of glassine sleeves that sat neatly on shelves and were, from the outside, not easily distinguished from books of text, which my mother never discarded. I have fewer than forty negatives made prior to 1954.

Perhaps these losses were incentives to start anew.

At the University of Missouri, I met a fine documentary photographer who coaxed me from my Century Graphic to thirty-five-millimeter photography.

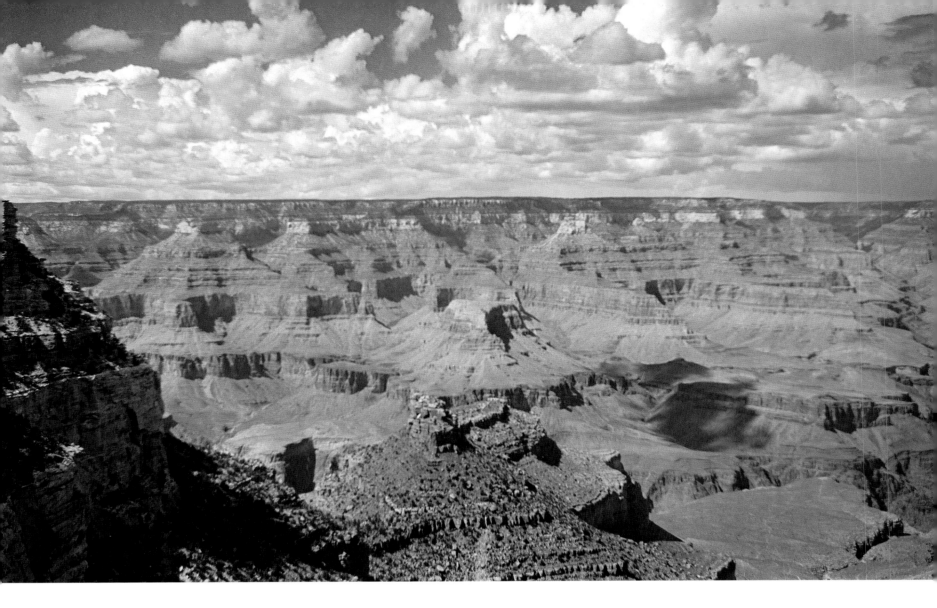

I would continue working entirely with 35mm and available light until 1956, when I returned to Nashville to complete my undergraduate degree at Vanderbilt University. While working part-time in a local camera store, I bought a medium format twin-lens reflex camera which provided ¼-inch square negatives, and until the early 1970s, I relied on those two formats, upgrading to Nikon and Hasselblad equipment as I began to work professionally.

It was studio photography that reacquainted me with the large format camera. I bought a 4 x 5-inch Sinar-F view camera in 1973 and almost immediately began using it for most landscapes. The best of my images prior to that time seemed to pale by comparison with those made on the larger film.

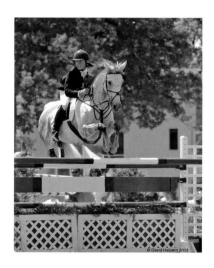

SHOW-JUMPER AT HEIGHT OF ACTION

Thirty-five-millimeter and medium format experience had given me opportunities to work quickly and respond spontaneously, particularly when photographing people and events. But it was the years with the more cumbersome Century Graphic and its accessories that forced me to develop discipline, timing and a sense of the moment. To this day I enjoy making pictures at equestrian jumping events and other activities where, without the aid of motor-drives I am still able to capture my subjects at the moment of peak action. Moving to the large format in the nineteen seventies required me to look more carefully, work more deliberately and, even when photographing landscapes, exercise the patience necessary to take advantage of the right light, a sudden calm on a windy day, the crash of a wave on rock or the position of a bird in flight.

The camera, properly used, is no more a mechanical 'tool' than the painter's brush or the etcher's knife, and the emotional-esthetic elements are derived from the imagination, the taste, and the technique of the artist, no matter what form of expression is involved. . .

. . . no photograph can literally 'look like' the subject; no negative can record all the values of the subject, and no print can faithfully render all the values of the negative. The photograph is something in itself as well as a 'transcription' of reality. Instead of thinking of photography as a limited means of portraying reality, we should think of it as a means of exceeding the limitations of reality—but only in terms of the medium itself.

— ANSEL ADAMS

I began to be influenced by the photographs and observations of Ansel Adams in the early 1950s, not long after I purchased my first "serious camera,"[7] but it would be years before I could fully implement the techniques I was reading about in various texts, and even longer before my own sensibilities matured enough to support an understanding of the philosophy inherent in these writings. I did, however, adopt guiding principles that intensified my interest and drew me deeper into a study of photography.

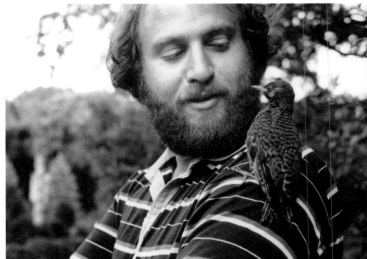

Twenty-five years ago, I received startled looks when I suggested that digital capture would replace film and the computer would replace tools most of us then regarded as state of the art. I have long believed in approaching one's art and craft with an open mind and enthusiastically anticipated changes that would expand the vision and creativity of photographers. For me, technology has never served to intimidate. I believe, as Adams wrote, that "craft facility liberates expression."

29

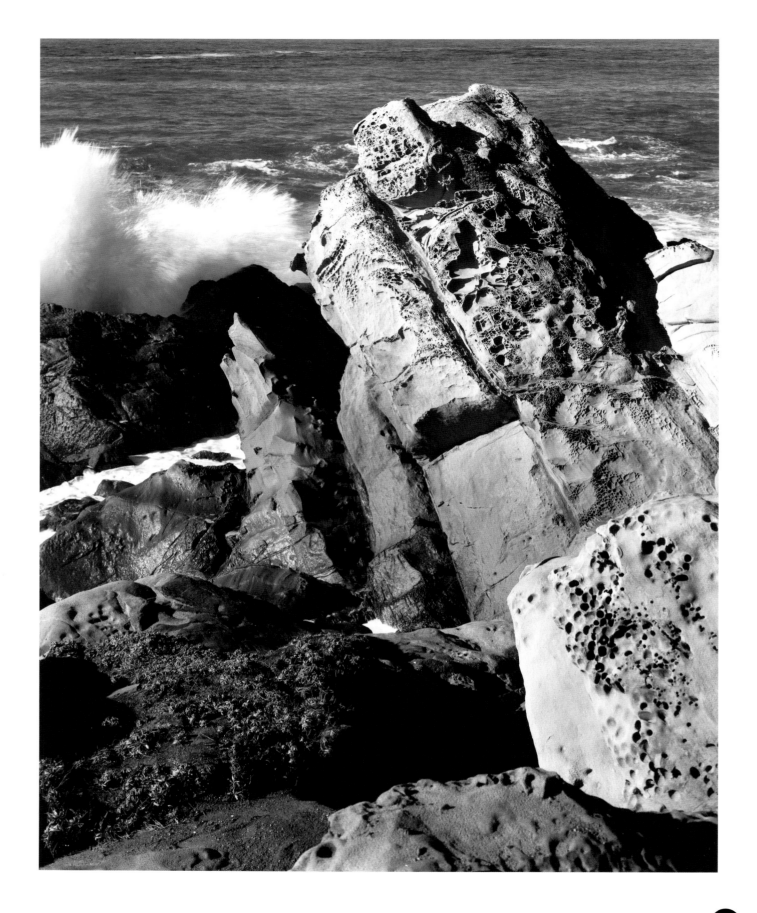

30

ROCKS AND SURF, SONOMA COUNTY, CALIFORNIA, 1986

Looking back from this point in life, I can imagine how fascinated Adams and his contemporaries would be with the technology that has emerged, particularly over the last two decades.

Though I had observed studio photographers working with digital photography earlier, I began my own exploration of that medium in 1997, when my wife presented me my first digital camera—partly as a joke. Sue felt I took the making of family snapshots much too seriously and decided I needed a piece of equipment I could use with little preparation and, more importantly, with considerably greater speed. That camera was what was commonly dubbed a "prosumer" product, implying that it was neither overly simple, nor something a professional likely would take seriously. I was delighted to find it had rather remarkable capability and could be "tricked" into doing things that were not described in the instruction manual. I soon demonstrated I could make images with it that compared favorably with those made on film, so long as I made prints that were 5 x 7 inches or smaller.

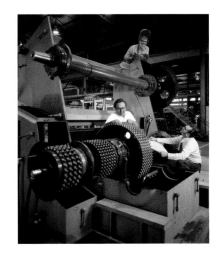

One day, I took the camera with me to an industrial facility to make pictures for a marketing brochure promoting a new product. I planned, however, to shoot the assignment on film.

Before starting, I asked my client how large the images would be when they were reproduced in his brochure, and he said that none would be larger than 4 x 5 inches. "In that case," I suggested, reaching in my bag for the toy-like digital camera, "let's make them with this." I explained that it would take less time and that would deliver digital files for his designer or printer later that very day. I'm certain he thought I was joking, but when I returned to his office that afternoon with a compact disk full of images and a handful of prints, he took one look and said, "In the future, you don't need to bring film with you."

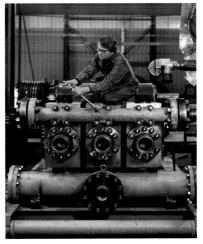

31

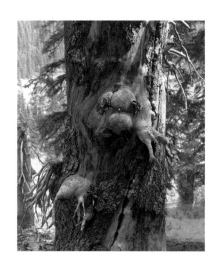

REMEMBERING JIM HENSON, 1991

That was more than seven years and nine digital cameras ago. Since then, I have worked to stay even with developing technology, honed my software skills and engaged in constant experimentation. In 2002, I processed my last images made on film and today my lab is entirely digital. My files of black and white negatives and color transparencies are gradually being scanned to digital files for archiving.

During the 1980s, I gained a reputation as a master printer through my black and white landscape photographs. As pleased as I am with the images I made and exhibited throughout the eighties and nineties, I am even more excited by the prints I produce today with ink-jet printers and a variety of excellent fine art papers. The viewing characteristics of these are remarkable, and some of the materials promise image stability and life expectancy of more than 100 years for color, and even longer for black and white.[8]

~~~~~~~~~~

From the very beginning, efforts to sell photographs as works of art met ambivalence from archivists and others whose concern is the preservation of art and the materials with which, and on which, they are created. Methods for producing black and white photographs that can last hundreds of years were developed in the first half of the twentieth century, and as scientific methods and chemistry improved, these became very reliable. Color stability is a greater problem in photography, as it is in all forms of art, and while processes like dye transfer and Ilfochrome[9] have significantly improved the stability and life expectancy of color images, many collectors remain reluctant to invest in this form of the medium. It was no surprise that as digital photography sought to achieve popularity its detractors quickly raised questions about the permanence of the digital print and also the stability of the original image file (comparable to the negative or

transparency in traditional photography) and the media on which it is stored. These problems are still being addressed regularly and are reasons for the photographer to exercise caution and vigilance.

In the past few years, print collectors have been introduced to the term giclée (jee-clay), a word derived from the French verb *gicler* (to spray), describing what is, essentially, a high quality ink-jet print. I am certain the word was invented because art dealers were fearful of using ink-jet to describe a fine art process. Legitimately, the process does need to distance itself from the output of the common desktop printer, but I dislike the pseudo sophistication of the word giclée and prefer simple, more descriptive terminology. Inasmuch as the traditional black and white photographic print is regularly called a silver or gelatin silver print, it might be apropos to call a print made on one's digital printer a pigmented ink print.[10]

Collectors should be informed clearly and simply with information substantiated by reliable research and expertise. After all, the protection and preservation of fine art is not an issue confined to photography, and no medium is truly permanent. Paintings and drawings are subject to degradation through excessive exposure to light, vermin, moisture and environmental chemicals, and metals such as bronze, brass and pewter can be damaged by chlorides and sulfides. The knowledgeable collector and conservator must exercise diligence in the care and preservation of any work of art.

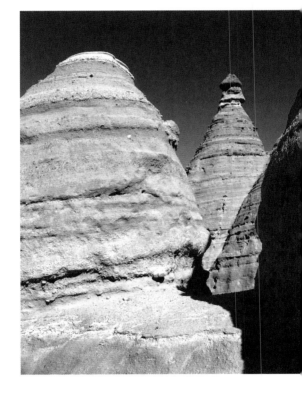

TENT ROCKS, NEW MEXICO, 1997

33

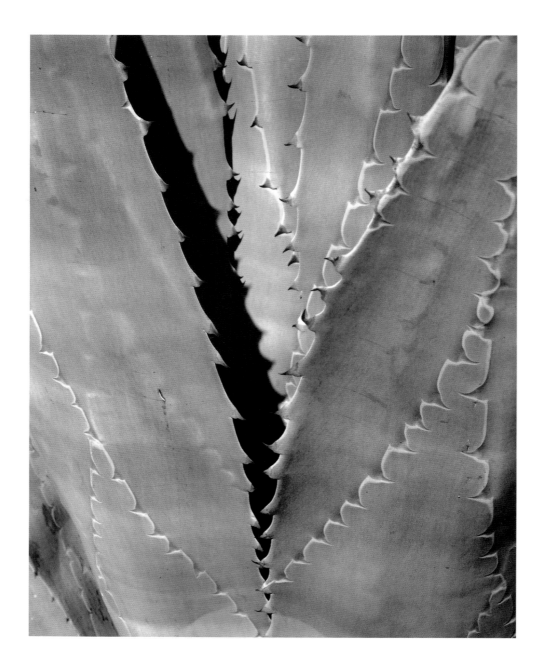

AGAVE, MONTECITO, CALIFORNIA, 1989

FACING, PEAKS ALONG KAUAI'S NAPALI COAST, HAWAII, 1989

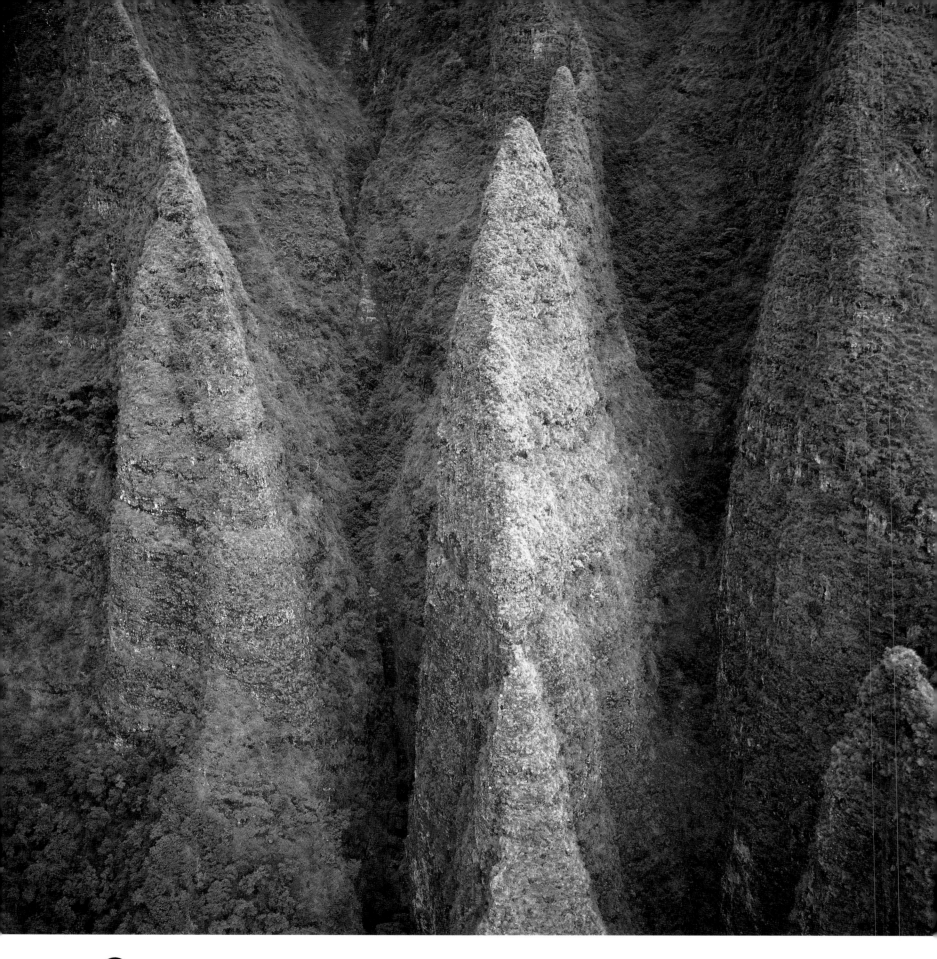

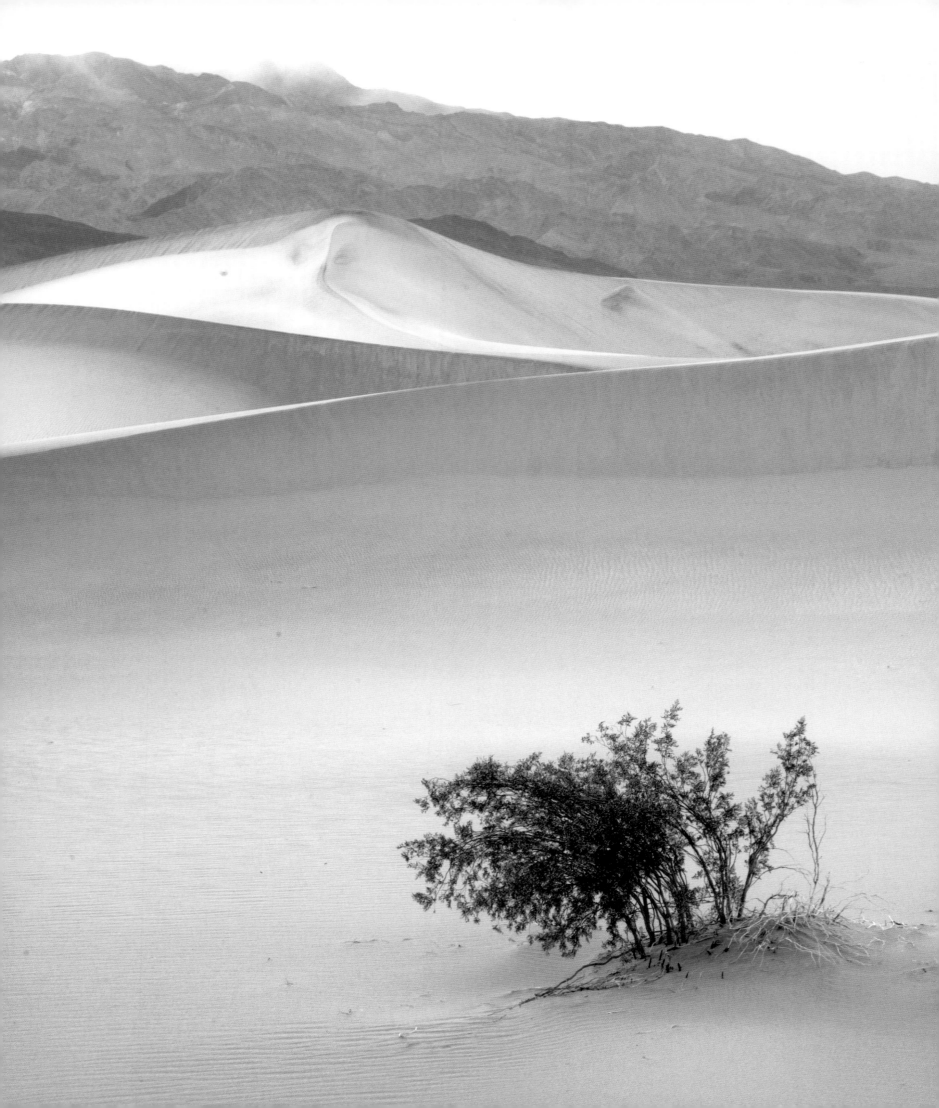

CACTUS DETAIL, ARIZONA, 2004

FACING, IN THE DUNES, DEATH VALLEY, CALIFORNIA, 2005

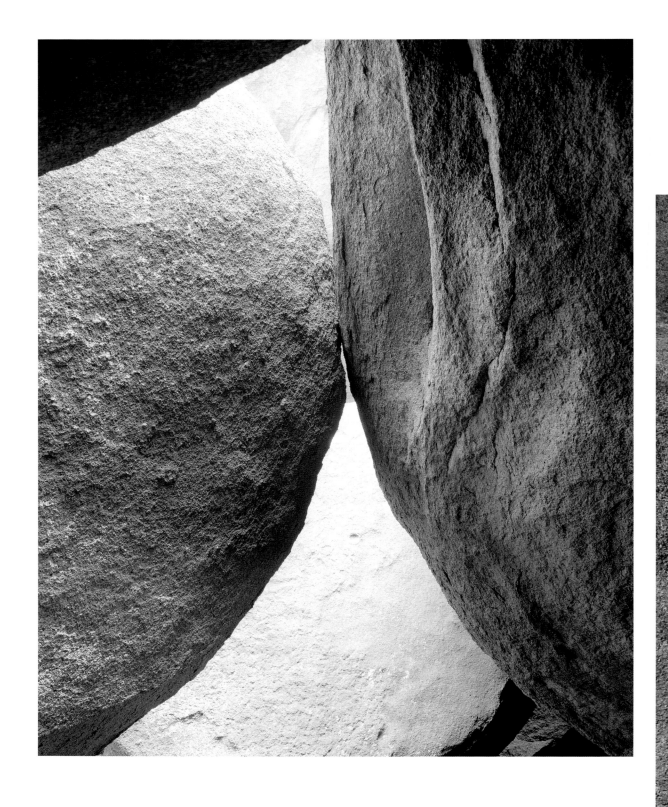

ROCK ROOM GRAPHIC, WICHITA MOUNTAINS NATIONAL WILDLIFE REFUGE, OKLAHOMA, 1995

FACING, ROCKS, RYAN MOUNTAIN, JOSHUA TREE NATIONAL PARK, CALIFORNIA, 2004

38

As an emerging medium, digital photography is likely to remain suspect for some time to come. After all, detractors still persistently deny the validity of photography as an art form, despite efforts by prominent and articulate spokesmen like Alfred Stieglitz and Beaumont Newhall as long ago as the 1930s. But, digital photography is proving its worth, and the freedom of expression it affords photographers who are grounded in the fundamentals of their craft will stimulate us to look at photographs in a way we never imagined just a decade ago.

Ethicists debate liberties taken in the manipulation of images. In the years before digital, the possibility that an image might have been manipulated was reason to attack its credibility, sometimes in the news and entertainment media and particularly in the presentation of courtroom evidence. So it is a certainty that the credibility of digital photography will be an even greater issue in years to come.

Art, on the other hand, is less about the literal presentation of fact than with the artist's sensibilities, perspective and interpretation of what is truth. As artists, then, photographers should be no more reluctant to embrace digital cameras and computer software than painters should be to buy new brushes, palette knives or paints that incorporate scientific formulations of pigments and preservatives. Each of us, however, makes our own choices and I do respect photographers who choose to follow traditional photographic methods.

Where the nexus of the painter's eye, brain and the hand that wields the brush has long determined what appears on the canvas, straight photography—out of necessity—has accepted the limitations of lens and film to record a prescribed perspective and range of values. Skills employed in the darkroom allow significant control in order to achieve self expression, but photographers have taken some restrictions for granted. To broaden the opportunities for expression, or to aid in

NEAR CLIMAX, COLORADO, 2006

overcoming certain handicaps, photographic science, especially over the last half century, developed a variety of fine lenses, and films and chemicals with remarkable capability to record and render colors and values. By the end of the twentieth century, no subject seemed beyond the modern camera's grasp, and the value of photography as a tool to record and communicate events and phenomena was unquestioned.

Enormously successful as photography has been as an instrument of communication, proving its ability to arouse the senses and motivate audiences, the potential power of the medium as art will become even greater as the image becomes liberated from the bondage of its own science.

DUNE WALKER, DEATH VALLEY, CALIFORNIA, 2005

FACING, BASS HARBOR LIGHT, MT. DESERT ISLAND, MAINE, 2001

EXPLORATIONS AND TOOLS

MORE OFTEN THAN BY PHOTOGRAPHS, I have been inspired by the paintings of artists like Albert Bierstadt and Thomas Moran. Studying their work offers a special insight into the qualities of light. I also discovered the importance of using my own eyes, as opposed to the lens of the camera, to observe perspective, color, texture and atmospheric conditions. I have been jealous of painters for their ability to depart from reality and still convey a sense of grandeur that their audiences find believable and consistent with their own perceptions.

Bierstadt depicted mountain environments with a majesty that defies the camera and lens. For example, his *Long's Peak, The Rocky Mountains* appears to have the straightforward perspective of a landscape as scanned by the human eye or seen through the normal lens of a camera. A photographer familiar with the place, however, immediately sees that the artist exaggerated the snow-covered peaks, making them rise even more majestically above the valley than they would if photographed through any lens capable of capturing the vista. One cannot fault Bierstadt for his interpretation, inasmuch as it reflects a perception many visitors take away from a visit to that part of Colorado, but to a photographer, it is frustrating to know that the artist accomplished something we could not because of the limitations of our equipment.

46

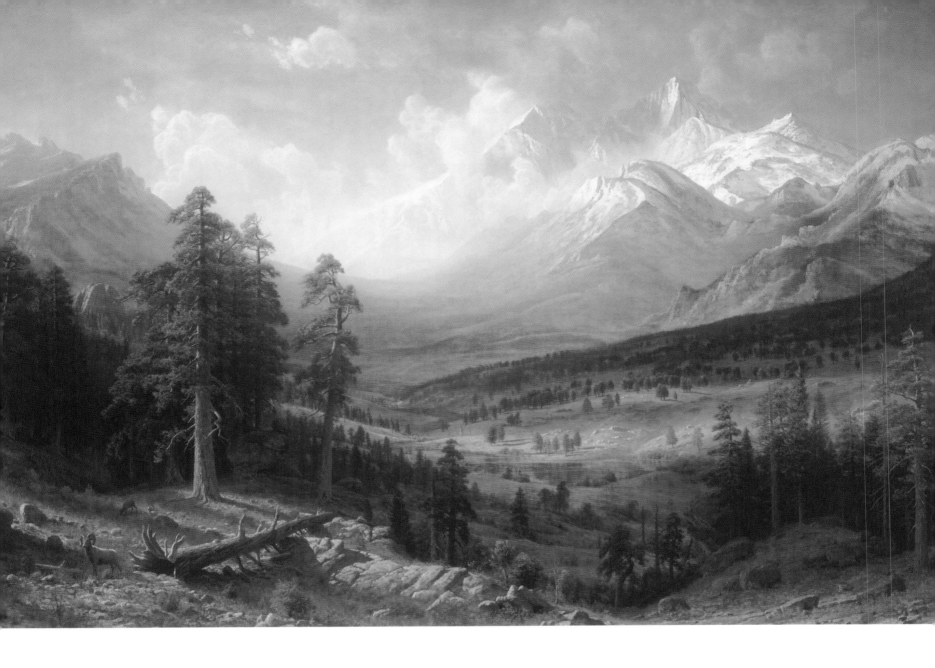

Standing on a hillside looking out at Long's Peak, a photographer can use a long focus or telephoto lens to dramatize the height of the mountain by seemingly bringing it closer, but cannot capture a broad expanse of foreground in that view. If you use a wide-angle lens to capture the broader foreground, the mountains will recede into the background and appear smaller. The perspective in each case is true, but no one lens allows you to combine the best features of both depictions into a single image. The painter has no such limitation and he follows his sensibilities in rendering a scene that matches his emotional response to the subject.

Early one morning, during a seminar field exercise in Rocky Mountain National Park, a group of students and I arrived at Dream Lake in the shadow of Hallett Peak. Low hanging clouds had blocked the rising sun and obscured the tops of the surrounding peaks at sunrise, but as we stood by the lake, the clouds began to break. Patches of sunlight began to spotlight the trees while cloud wisps continued to drift over the rocky pinnacles above. I made a number of exposures, recording the changing light patterns and drifting clouds.

A few weeks later, I manipulated one of the photographs using Adobe® Photoshop®, attempting to produce an image that more accurately reflected my perceptions of what I had seen, not through the camera's viewfinder, but with my own eyes. I recalled that without raising my eyes to the mountain tops, lowering them to the water at my feet or turning my head to the right and left, I could only take in a part of what my camera and it's wide angle lens captured. My unmanipulated image, on the other hand, gathered everything and recorded it in a manner I'd come to expect and accept, but lacked the drama of the real experience. The mountain didn't seem tall enough and the foreground wasn't wide enough. I selected portions of the image and stretched them, leaving only the trees and lake in the mid-ground as they had been recorded. The result (on page 51), which incorporates the perspective rendering properties of three different lenses in a single image, seems totally justified in the artistic sense, for it more accurately reflects my perception of the scene.

I use this example to express a point of view and to demonstrate that departure from technical paradigms offers new expressive freedoms. This is not to oppose Ansel Adams' admonition against using photography to imitate painters. To the contrary, recognizing that our tools have improved vastly since Adams counseled us to think of photography as a means of exceeding the limitations of

reality, but only in terms of the medium itself, I'm suggesting that we do just that with our new and improved tools, all the while preserving a style that is classically photographic.

I have no doubt that the art of photography will be redefined in the twenty-first century and I hope that it will not continue to be as defined by the camera and lens as it was in the past.

Over the past twenty years, I've found my greatest challenge in developing a style and methods that would allow me to grow as a photographer; not abandoning the work I've always enjoyed doing, but finding new and different ways to do it better. If one accepts the premise that photography is more about light[11] and the way it defines our subjects, then one may be liberated from the instruments of the craft and find wonderful opportunities in simple things, abstractions and even mundane vistas.

Just as I do not suggest returning to the once common practice of imitating the style or manner of traditional painting, which always seemed an apology, I do not espouse the alternative printmaking processes that have, in the last several years, regained great popularity. Platinum palladium prints can be exquisite; Cyanotypes, and other non-silver processes are interesting, but these hold no special fascination for me in a time when we are making giant strides with newer printmaking methods. I wish to use all that I have learned in the past fifty years as a springboard to participation in the next era of photography.

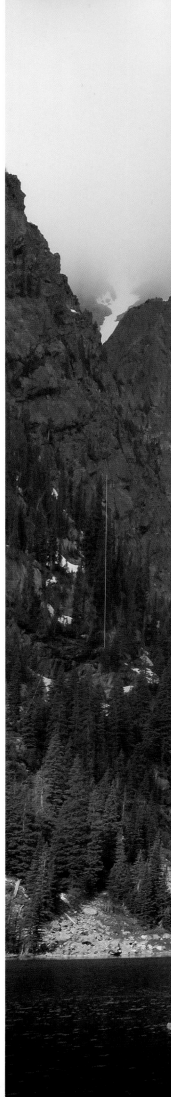

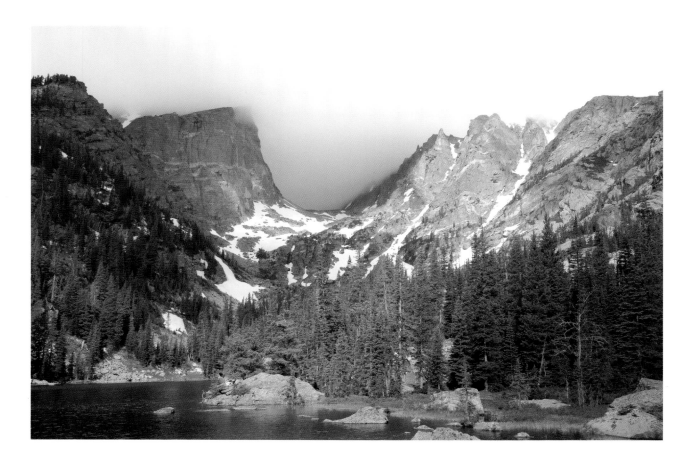

DREAM LAKE, ROCKY MOUNTAIN NATIONAL PARK, COLORADO, 2005

ABOVE, THE ORIGINAL IMAGE MADE WITH A WIDE ANGLE LENS.

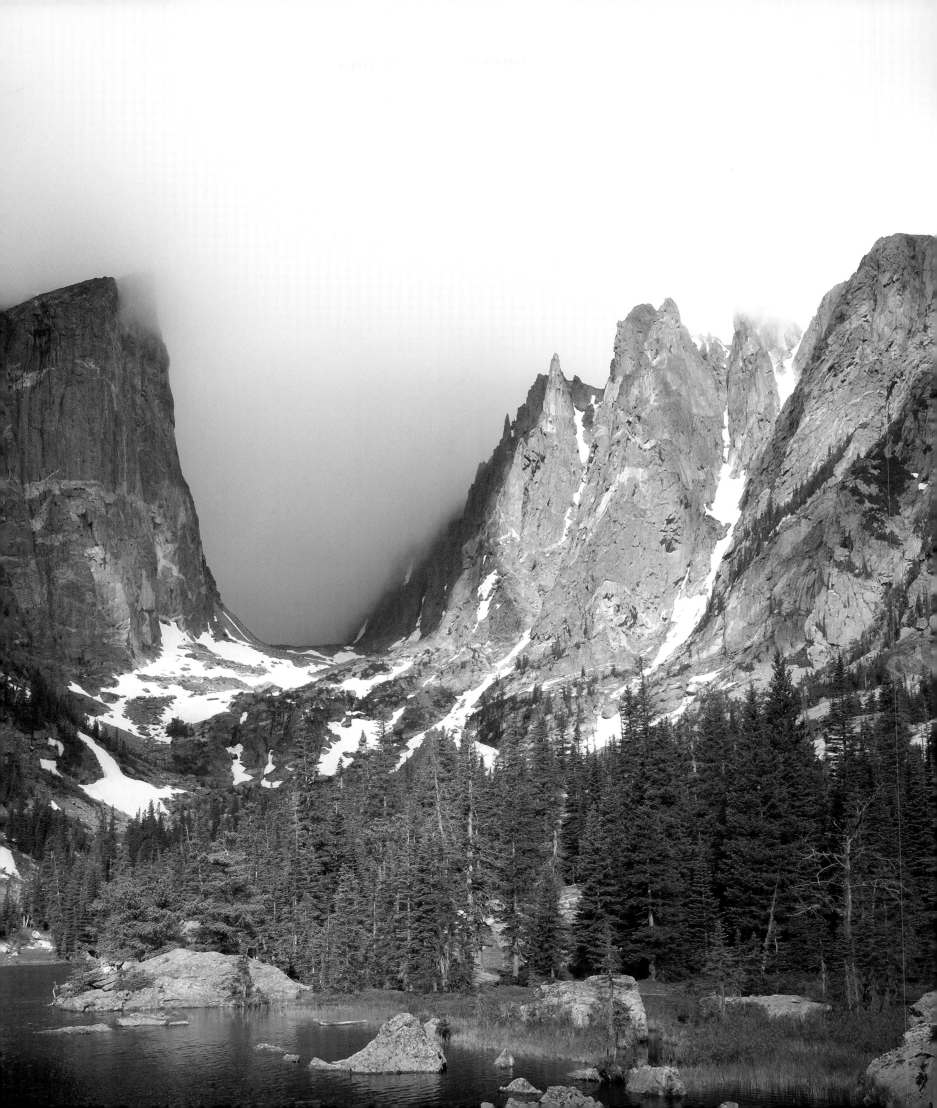

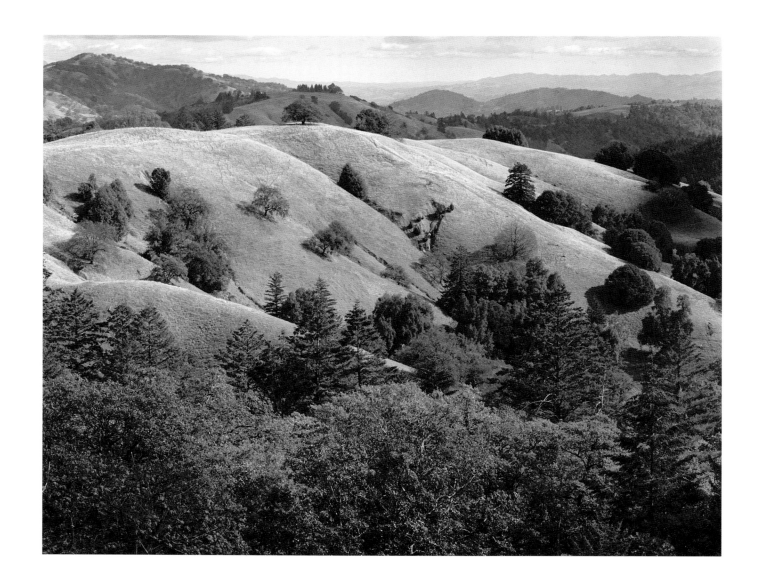

52

CALIFORNIA HILLS, SONOMA COUNTY, 1997

FACING, IN GOLDEN CANYON, DEATH VALLEY, CALIFORNIA, 2005

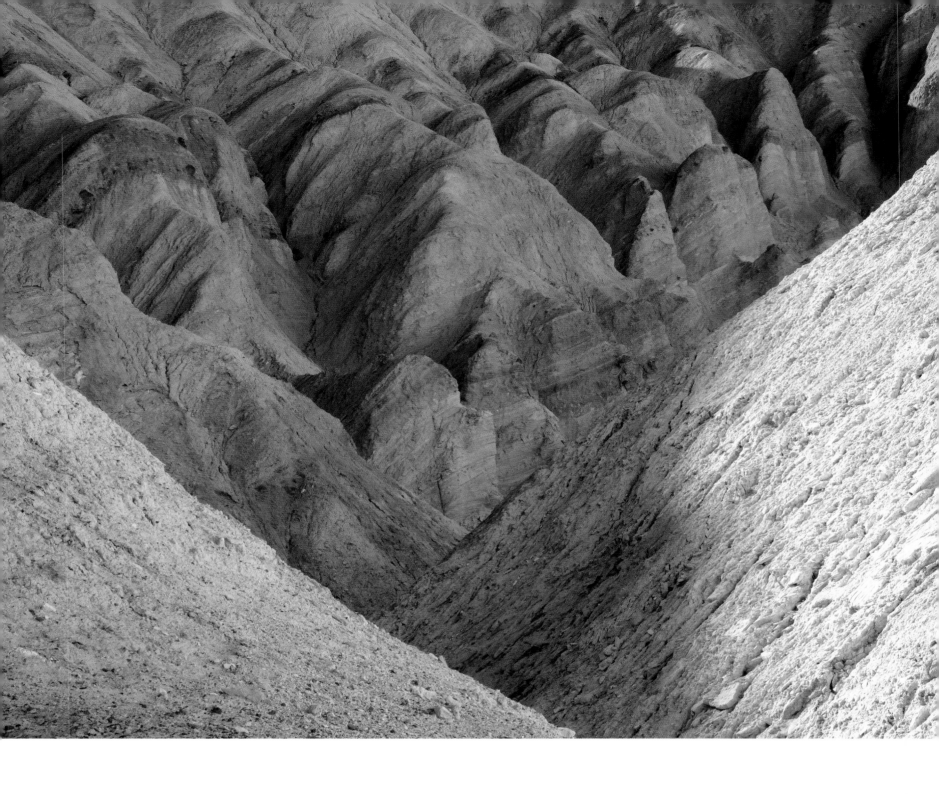

53

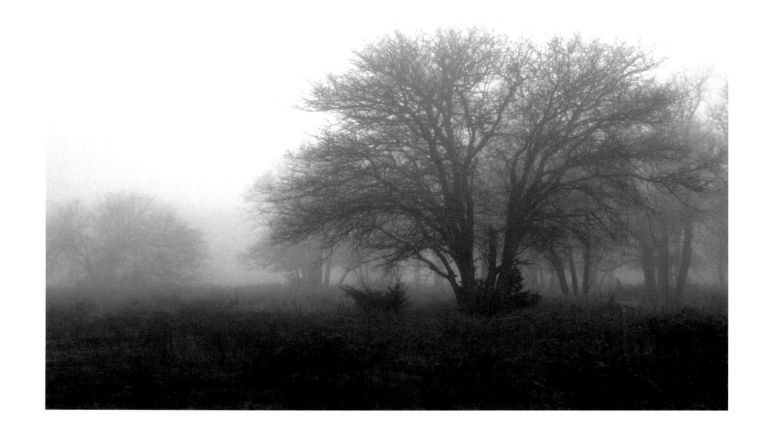

54

MORNING MIST, WICHITA MOUNTAINS NATIONAL WILDLIFE REFUGE, OKLAHOMA, 1973

FACING, NEAR BARTLESVILLE, OKLAHOMA, CA. 1985

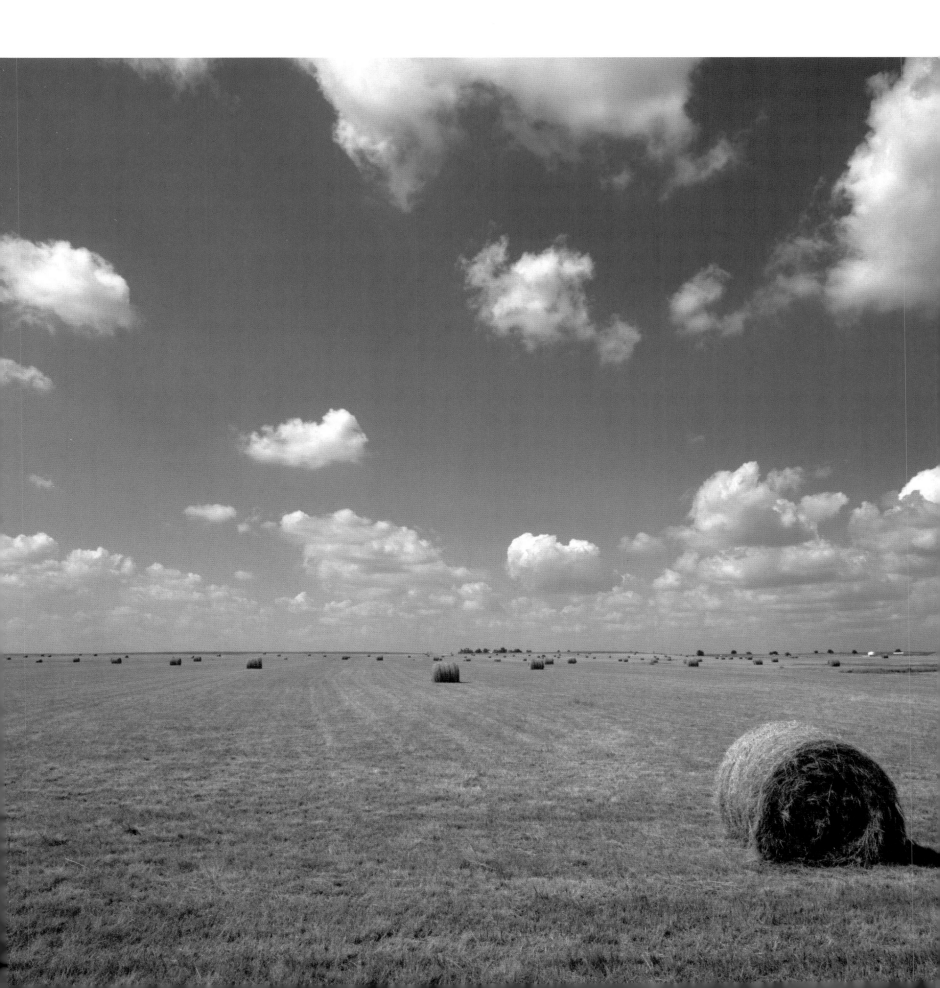

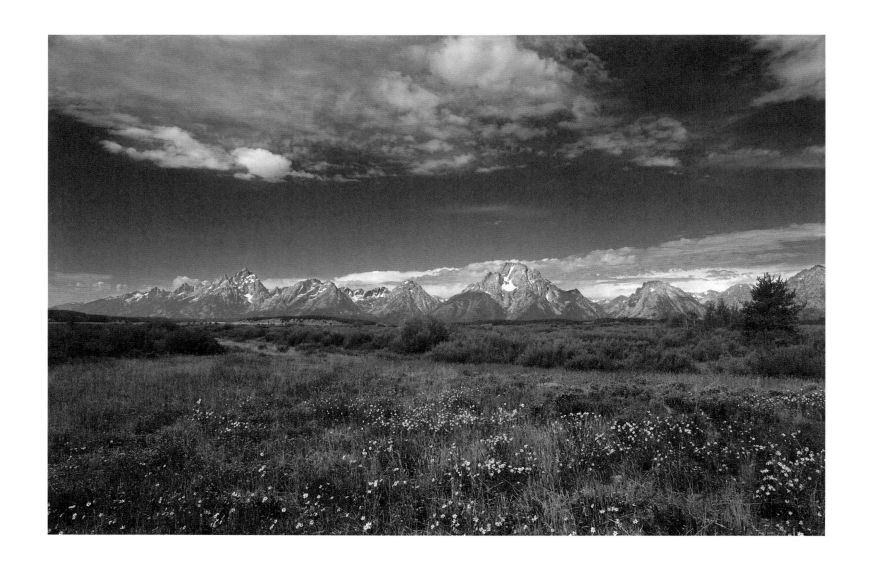

56

MT. MORAN AND THE GRAND TETONS, WYOMING, 1972

On a trip to New York State around 1969, I went to the George Eastman House in Rochester, where a visitor can explore the entire history of photography. Before that I'd never seen a real Daguerreotype or an Edward Weston Print, or a Julia Margaret Cameron portrait or any number of images I'd read about or seen only as reproductions.

I arrived at the museum one morning as it was opening and after about an hour asked my family to leave me there until closing time while they continued their other planned activities. Exploring every photograph and artifact on display and asking questions of the staff, I was hardly aware of the passage of time. Upon returning home, then in St. Louis, I considered discarding all my old negatives and starting again. I didn't do that, but I was tempted.

Non-photography related experiences can deeply influence our perceptions of our subjects as well. Most memorable for me was an introduction to Gestalt psychology and the writings of Fritz Perls[12] at a workshop in the early 1970s led by Frank Rubenfeld, a disciple of Perls. This one event more than others helped me open my eyes and become more conscious of all my sensory perceptions. Over the years that followed, I literally learned to see the environment in a new way and became increasingly conscious of all my responses to each subject I photographed. I began to incorporate Gestalt exercises into my teaching, and as I learned to look at everything around me in many ways, I also learned that not everything needs to be photographed. I believe that to be one of the most profound realities that photographers discover as their vision improves.

The exercises I've adapted from Gestalt therapy help individuals develop both a stronger sense of their environment and greater awareness of their own responses to it. In one, students are asked to look about and say aloud the first thing

that they see. Beginning with the phrase, "Now I see..." the student is encouraged to express the subject of his focus without restraint or embarrassment. The proclamations continue again and again until the student either develops a list of several items or begins to have difficulty continuing to find subjects to name.

Typically, this exercise begins with the naming of objects. If it is conducted in a classroom, students usually see walls, specific items of furniture, windows, pencils, and books, for example. Each is subsequently asked to focus on a single object such as a chair and, beginning with the same "Now I see...", to describe its qualities. This results in descriptions of colors, textures, conditions (old, new, shiny, dirty, dull, etc.) and usually, after several moments of concentration, a student's attention will be drawn to the play of light on the surfaces of a subject and on shadows cast by it. Then suddenly comes a wonderful exciting moment when the student recognizes the point of the exercise and his or her vision becomes vivid and sharpened.

Other individual and team exercises help students to abandon common descriptions and ways of looking at mundane objects so that they can see the familiar in new ways. (If, for example, you didn't know that the word for dog was dog, what would you call it and how might you describe it?)

Still other exercises are concerned with individual response to objects in the environment, based on the rationale that a photograph or any other representation will communicate more effectively if the artist has the ability to reflect either a physical or emotional response to a subject.

I have learned that it is not enough to go to beautiful or wild places and simply make pictures.

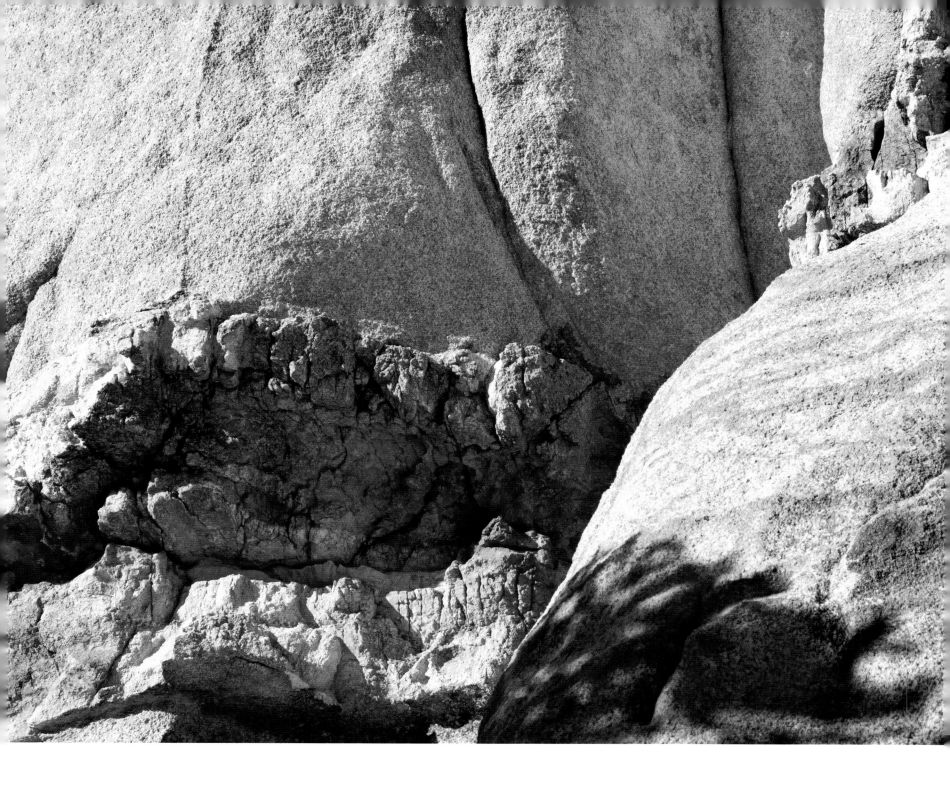

59

60

My professional career had a late start,[13] but by 1975, I had published a magazine article, been accepted in my first museum exhibition and had two one-man shows. As I established credibility as a photographer, invitations came to teach and lecture. I accepted an adjunct university teaching position—as a part-time job—and by the end of my first semester was hooked. Teaching encouraged me to look more thoughtfully at history, processes and philosophy. I no longer took anything I had learned for granted, for my students were certain to ask piercing questions that deserved well constructed honest answers. I had to review and critique techniques I had come to practice by rote over the years.

Around 1986, I abandoned thoughts of obtaining an advanced degree so that I could become a full fledged academic. While visiting a university and having lunch with three ranking faculty members, I expressed a desire to get into a masters degree program. "We could take you into our masters program," one of them volunteered, "but you'd be bored to death and you'd be taught by instructors who probably have less knowledge of photography than you have." Another, sensing my frustration, admonished, "Just go teach; someone will give you the opportunity." Indeed, I was given several opportunities to lecture and even spent one year as a full-time university instructor. Since 1990, I have served continually on advisory committees, and that allows me more time to travel and be engaged in the photography I enjoy most.

On occasion, I've attended workshops conducted by other instructors and practicing professionals. These experiences have provided insight into how others think and approach their craft. Those I admire most are the instructors who are least self-indulgent, sharing their knowledge freely and taking extra time to advise and encourage struggling beginners. I remember a comment attributed to Ernst

Haas,[14] who said he never criticized a student's work too harshly, for how could he be certain that what he saw as a poor execution was not, in fact, a good beginning?

Learning flourishes best when there is dialogue between instructor and student, when concepts are discussed and questioned and information is validated through clear understanding of background, terminology, content, and purpose. I never discourage a student who has the heart to put forth his work and ask for an opinion. All of us have something we want to say, even though we may still be developing the knowledge, skill, and vocabulary with which to say it. Though it requires patience and extra effort, an instructor should always find some element in a student's work to critique constructively.

LAVA DETAIL, CRATERS OF THE MOON NATIONAL MONUMENT, IDAHO, 1972

FACING, BALANCED ROCKS ON ELK MOUNTAIN, WICHITA MOUNTAINS NATIONAL WILDLIFE REFUGE, OKLAHOMA, 1988

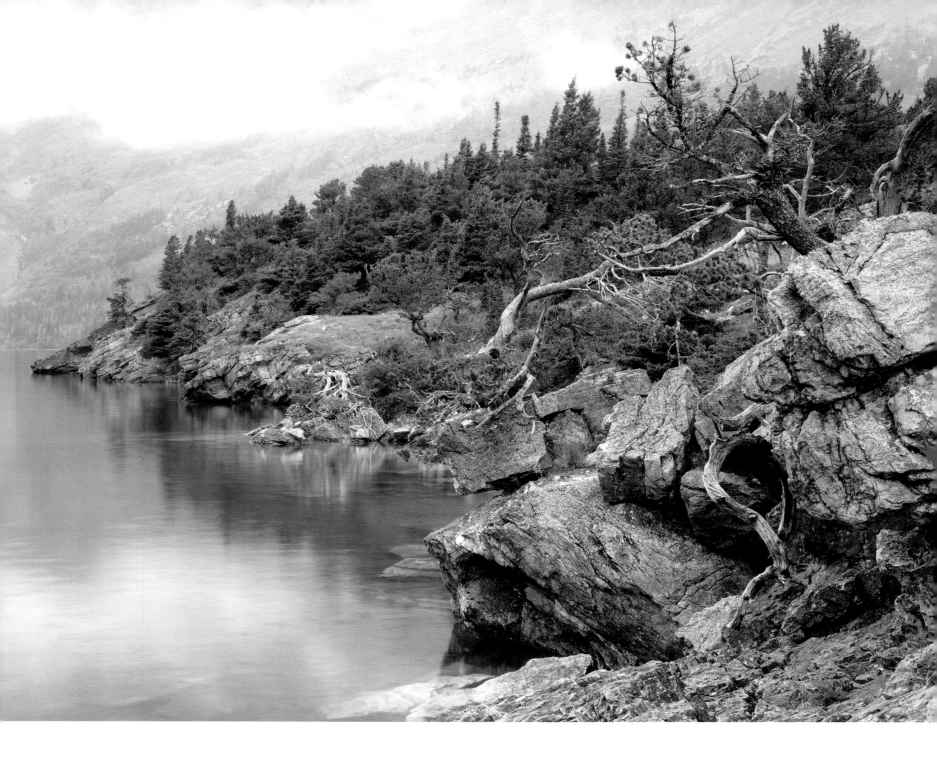

**64**

ST. MARY'S LAKESHORE AND FOG, GLACIER NATIONAL PARK, MONTANA, 1992

FACING, IN TENNESSEE, CA. 1970

In the seventies, I discovered the importance of taking the time to get to know a subject before putting it on film. And knowing a subject is more than recognizing the fact of its existence. When I look at a subject long enough to get beyond the initial aha or wow, I find something deeper, more moving and essential. I find it relates to and contrasts with other subjects that influence my perceptions of composition and design. And, most important, I study the light because light is the most important tool of our medium.

Light is always defining. It governs our perceptions of shape, form and texture, and it establishes the mood of the scene and of the photograph. Light can be very quiet or it can scream. Light also can be angry or sullen. As important as where light strikes a subject is where it does not illuminate, and often, when it strikes is critical. Though we have been told there is a right time to photograph everything, I am aware that there is not just one right time, and I know that the light is never quite the same from moment to moment, day to day, month to month and year to year. Light is the law, but it most certainly is neither rigid nor static. It simply rules what we photographers do.

Not all the subjects that capture my attention are extraordinary in the physical sense. The mountains are rarely the highest; the rocks are not the largest, the streams not the wildest and the forests not the oldest. But each is special by virtue of the circumstances or conditions under which I discovered it. On one rainy afternoon in Glacier National Park, I was perched on a rock shelf extending into St. Mary Lake, frustrated by the inclement weather, but determined not to leave without an image. (While not everything needs to be photographed, there are times when I need to make a photograph.) I sat beneath a poncho watching the low hanging clouds float over the water and suddenly I realized I was looking in the wrong direction. Behind me on the shore were twisted trees and beyond

them, providing a background was a mountainside subtly filtered through rain and clouds. I repositioned my 4" x 5" view camera and exposed, on two sheets of film, a view I had not seen before, and have not since, from that place.

A former assistant once observed a preoccupation with triangles and black skies in my work, a conclusion I concede could be drawn from it. But, in spite of having a strong sense of graphic composition, I am not conscious of any preoccupation when looking at a subject or scene, but simply compose for the moment. If a triangle happens to suit the composition, if a dark sky provides contrast and focuses attention where it is desired, they are enlisted to achieve the effect. I do prefer vertical compositions, however, and in recent years have sometimes had to force myself to see things horizontally.

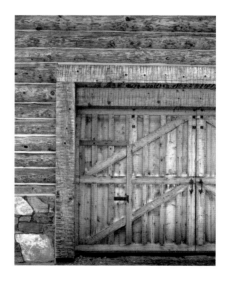

Though I have embraced digital photography and moved completely away from film, I still consider my approach traditional. A photographer should have a solid understanding of the principles of photography and use them to produce—in the camera—the best possible exposure of a subject. The computer should never be a crutch for inept execution, but a photographer should never fear to use the computer and software to create, not only the effects we always attempted to produce in the darkroom, but results that are beyond the limitations that the camera and traditional film/chemical photography allowed.

There is a line I have not yet defined, but have no wish to cross, that lies somewhere between the unmanipulated rendering of a scene as the lens captured it and the completely distorted illustration that can be created from that rendering on a computer. Both extremes can be justified, but I am interested, primarily, in doing what I always have done. . . better.

BARN DOOR, RIDGWAY, COLORADO, 1996

FACING, BARN WALL, JENKS, OKLAHOMA, 1978

The appropriateness of any approach to the medium is something that will be debated by critics and aficionados and it is probable that no one answer will satisfy all. I will continue to explore the possibilities and it excites me to know that the technology is likely to outdistance my imagination and continually open new doors.

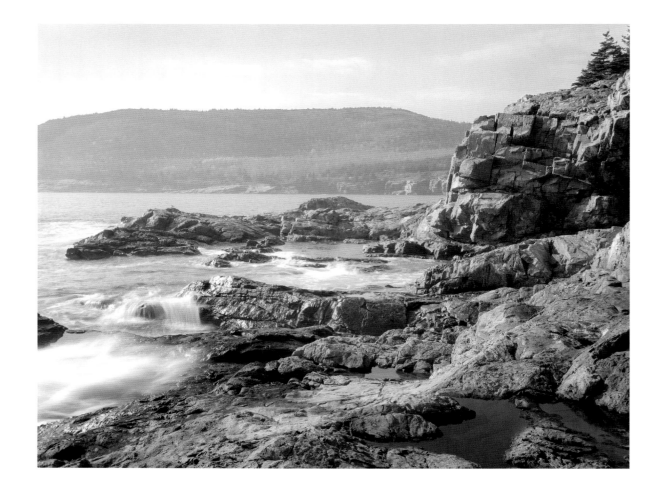

AT GREAT HEAD, ACADIA NATIONAL PARK, MAINE, 1994

FACING, BEYOND FISH KILL ROAD, THE SEA RANCH, NEAR GUALALA, CALIFORNIA, 1987

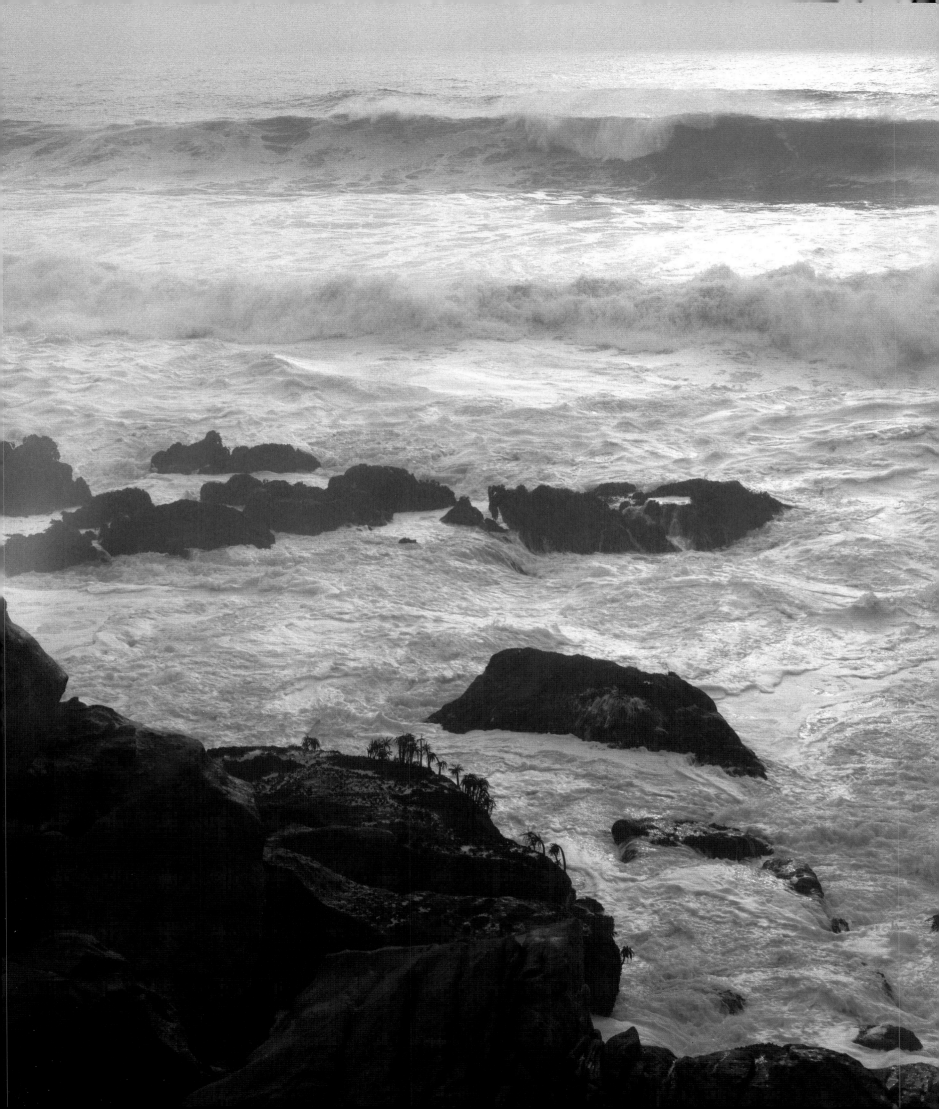

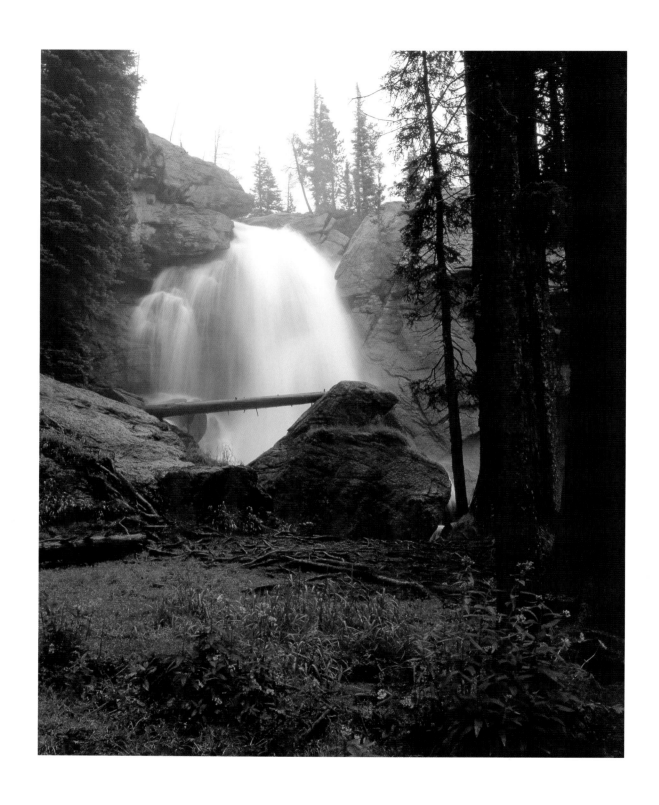

OUZEL FALLS, SUMMER RAIN, ROCKY MOUNTAIN NATIONAL PARK, COLORADO, 1984

THIS PHOTOGRAPH WAS MADE IN A STEADY RAIN ON JULY 26, 1984. IT WAS MY
BIRTHDAY AND MY FIRST SESSION IN "ROCKY" AS ARTIST-IN-RESIDENCE. IT IS ONE OF
MY FAVORITE IMAGES, DEMONSTRATING MY PREFERRED METHOD FOR PHOTOGRAPHING
WATER; EMPHASIZING ITS MOTION IN CONTRAST WITH THE STATIC AND SOLID QUALITY
OF THE SURROUNDING ELEMENTS. I'VE ALWAYS PREFERRED THE BLACK AND WHITE
INTERPRETATION TO THE COLOR IMAGE AT LEFT AND HAVE NEVER PRINTED THE COLOR
VERSION FOR EXHIBITION OR SALE.

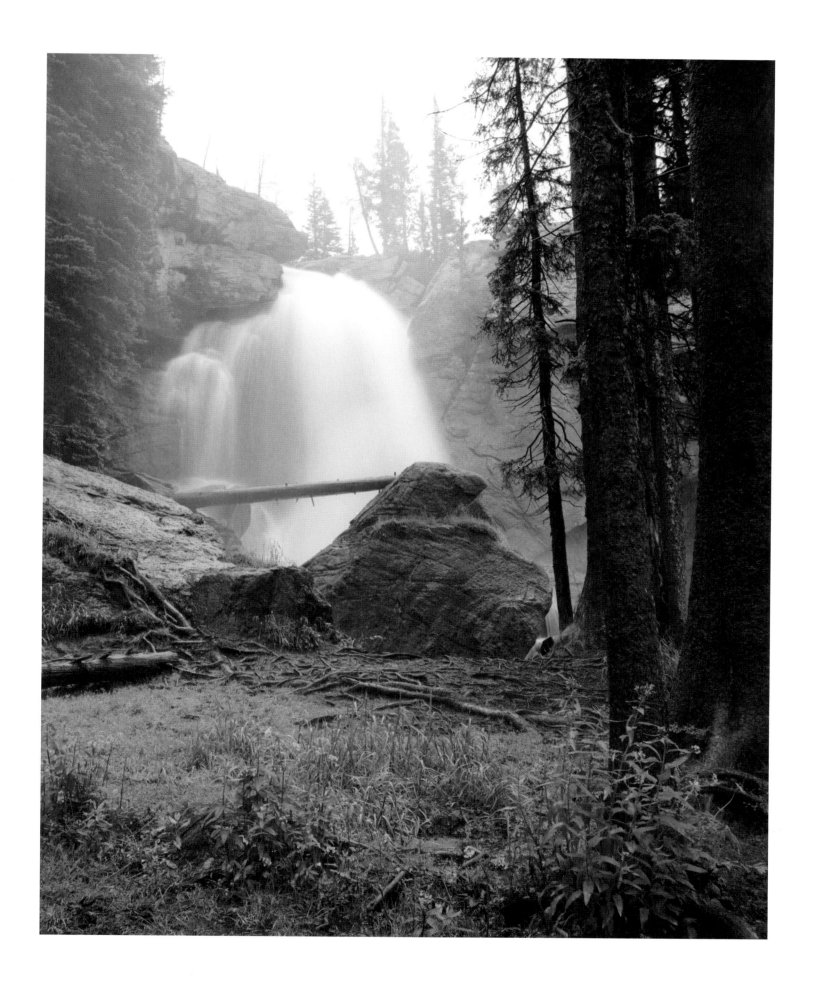

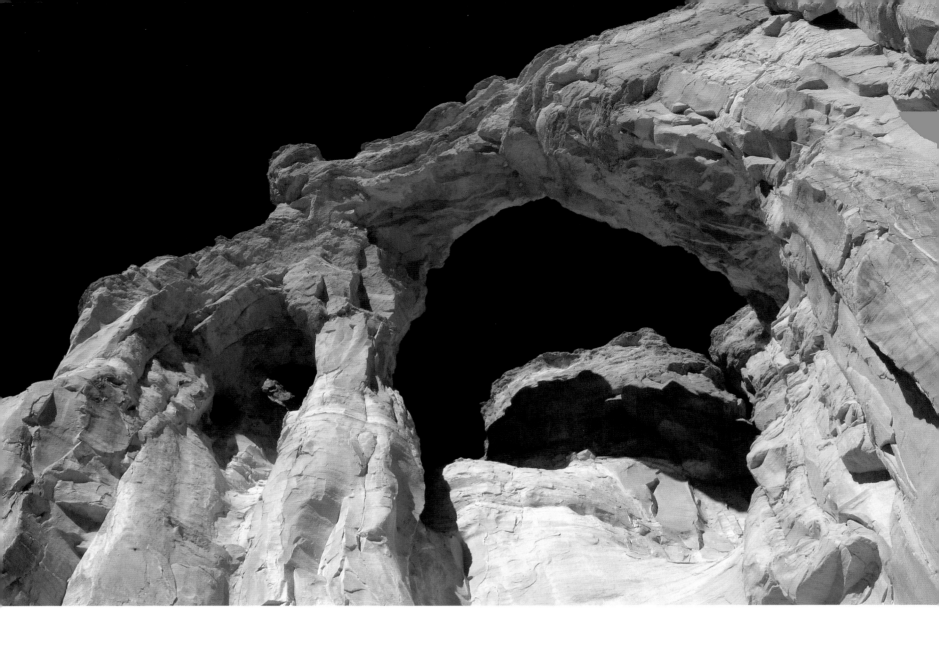

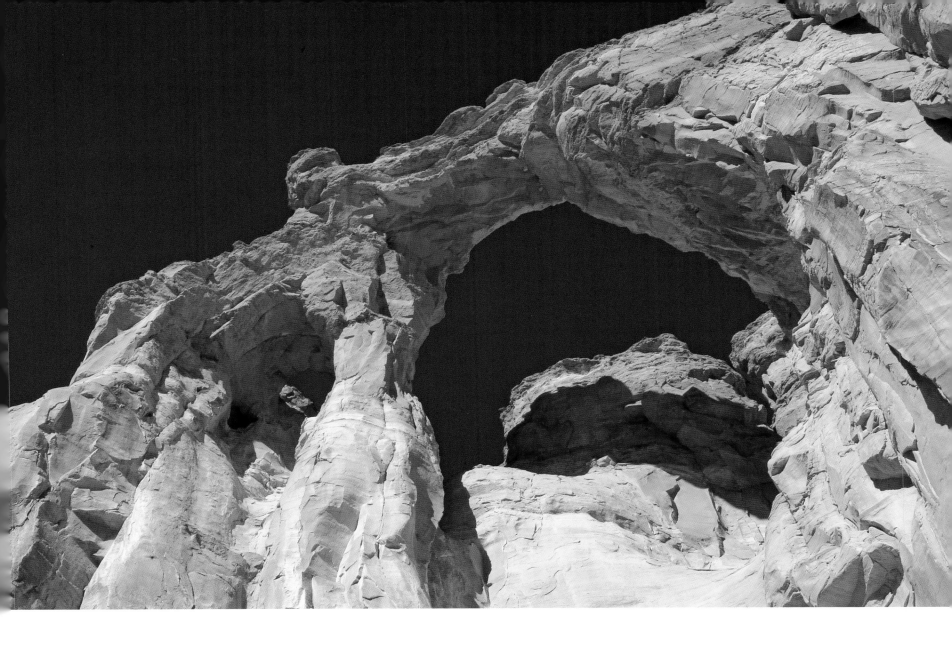

73

GROSVENOR'S ARCH, UTAH, 2004

THIS IS AN IMAGE THAT, BECAUSE OF ITS SIMPLICITY AND HIGH CONTRAST, SEEMS
EQUALLY EFFECTIVE IN BLACK AND WHITE OR COLOR.

~~~~~~~~~~~

Those of us introduced to photography before amateur color prints had become commonplace learned to see in black and white. That means that when we looked at a subject and the light falling on it, we were able to discern the black and gray values each color would impart to a black and white print. This ability was born of necessity and gifted to the photographers of my generation.

Some photographers only make pictures in color. Others work exclusively in back and white. For a long time I was a member of the latter group. I reasoned that black and white afforded greater opportunity for self expression. Color seemed so literal, standing in the way of interpretation. You could manipulate a black and white image so that its values expressed the emotions you wanted to convey without destroying the subject's reality, but manipulated color could become unreal or unbelievable. Often the feelings expressed by color seemed to belong more to the medium itself than to the photographer who chose to express himself through it.

In retrospect, I see these attitudes as due largely to an inability to control the color process. Black and white photography was in the hands of the photographer. We could capture an image, process the film, and make the print without turning over the responsibility for any part of our creation to another person. Color processing and printing, on the other hand, often depended on laboratories. Now digital photography has given us the tools to interpret color as never before. While I often prefer the subjective qualities of the black and white image, I work in color when it truly adds value to the interpretation. However, I still cannot comfortably use color for its own sake.

Some photographers say there are subjects that cannot be photographed in black and white. Except for photographs of colors themselves, I believe that any subject can. There may be little to recommend photographing a vivid sunset

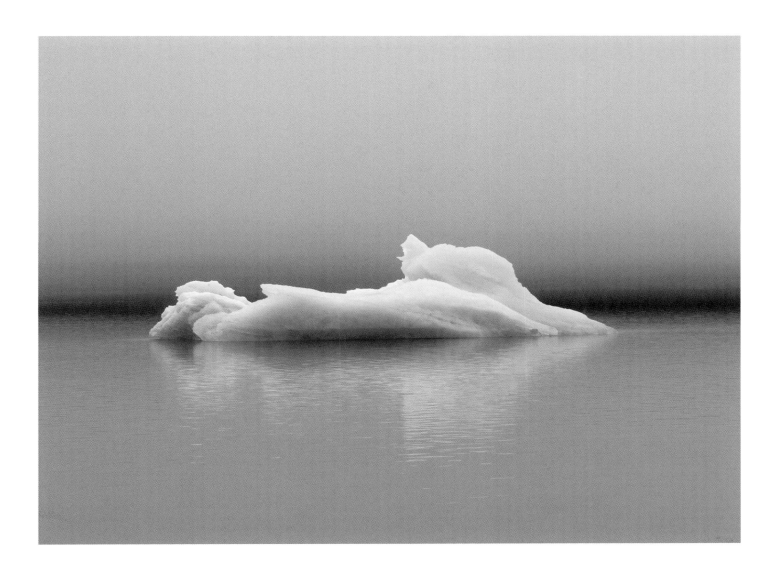

sky in black and white, but under certain circumstances even a photograph of a rainbow can be dramatic and wonderful without color. Of course not all agree with this point of view. I am thankful that all of us have our own motivations and perceptions.

75

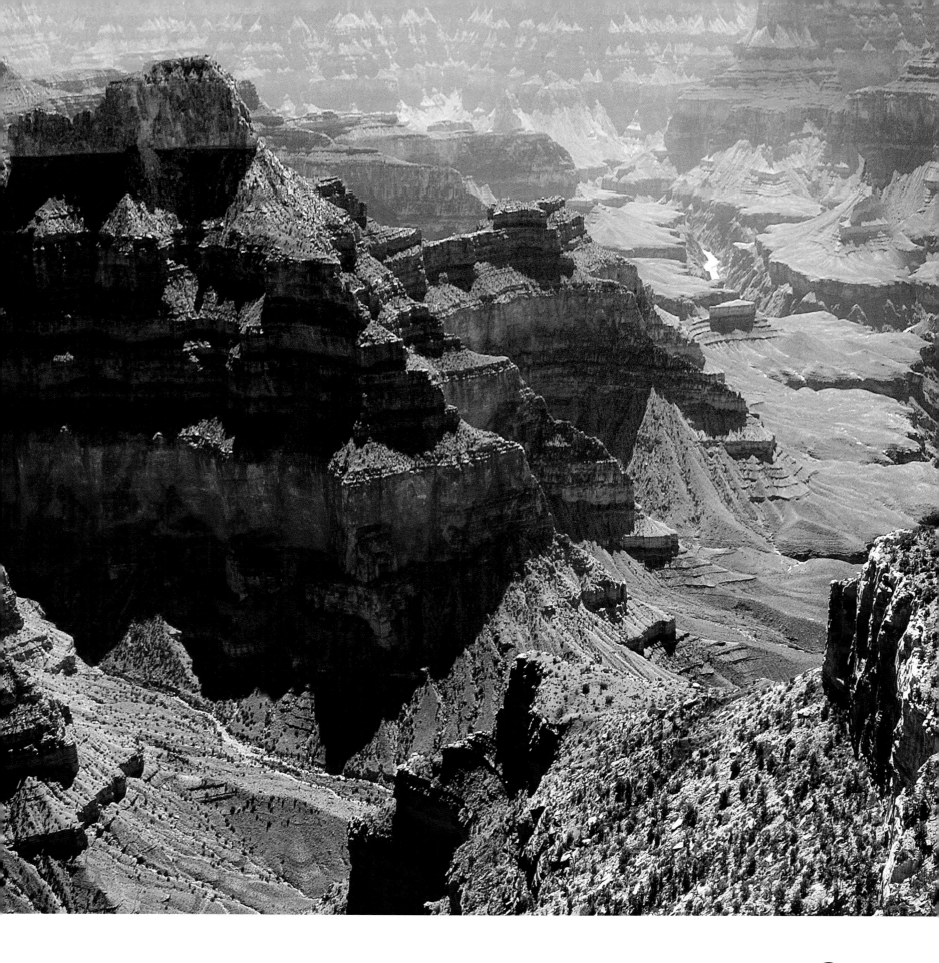

76

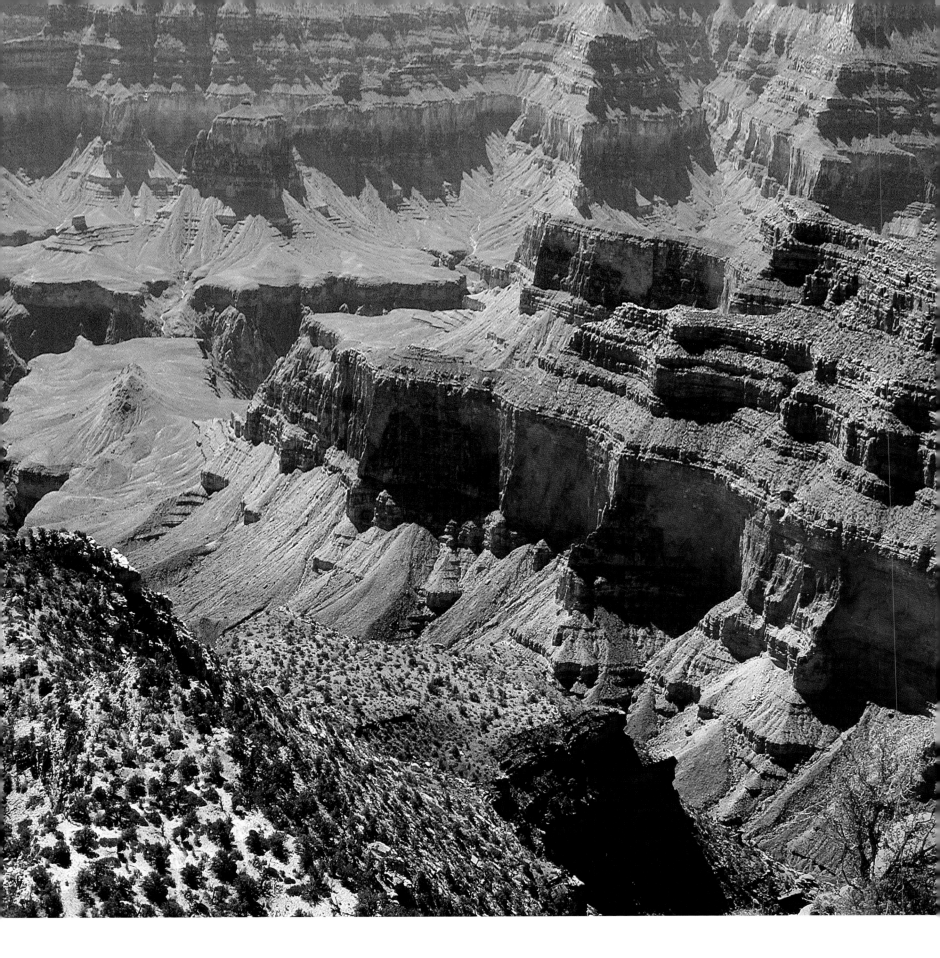

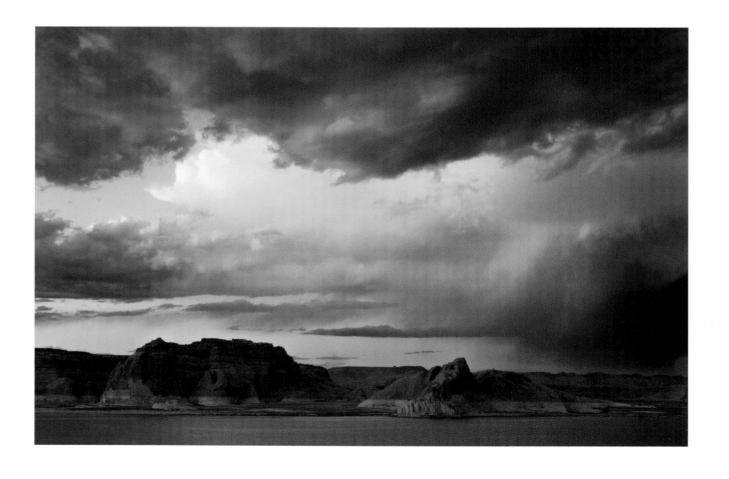

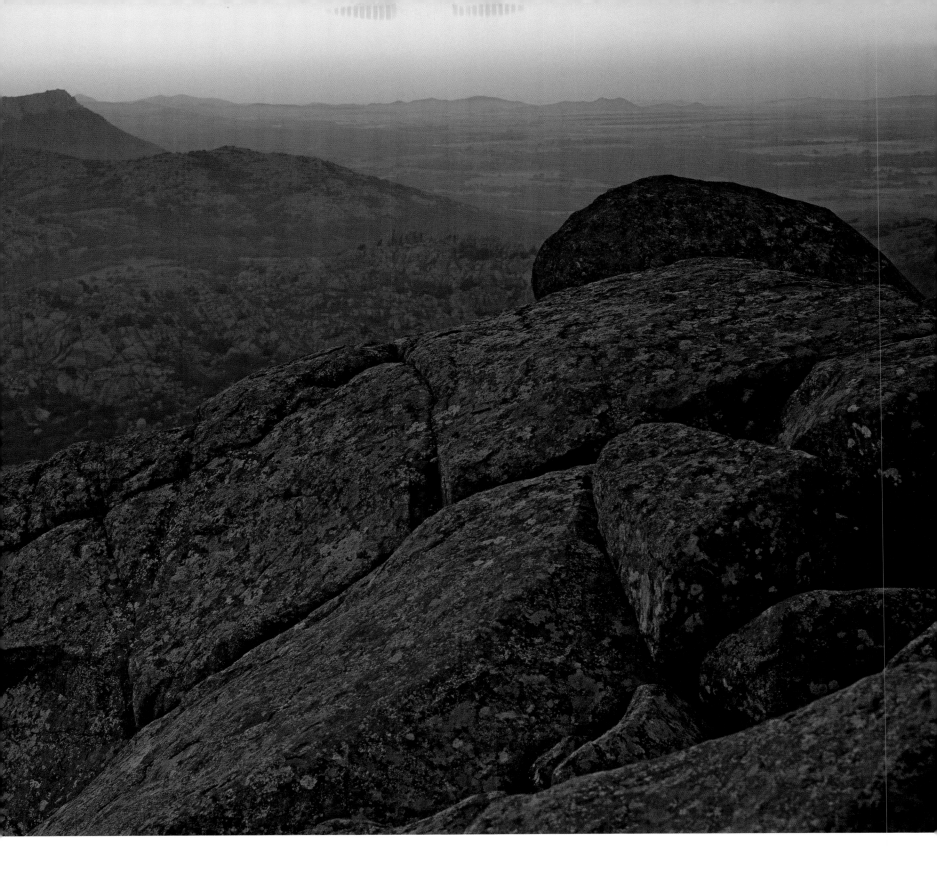

SUNSET OVER LAKE POWELL, ARIZONA, 2004

FACING, SUNSET FROM MOUNT SCOTT, WICHITA MOUNTAINS NATIONAL WILDLIFE REFUGE, OKLAHOMA, 1990.

MT. SNEFFELS AND THE SAN JUANS, NEAR RIDGWAY, COLORADO, 1991

FACING, ICE AND ROCKS IN ROARING RIVER, ROCKY MOUNTAIN NATIONAL PARK, COLORADO, 1987

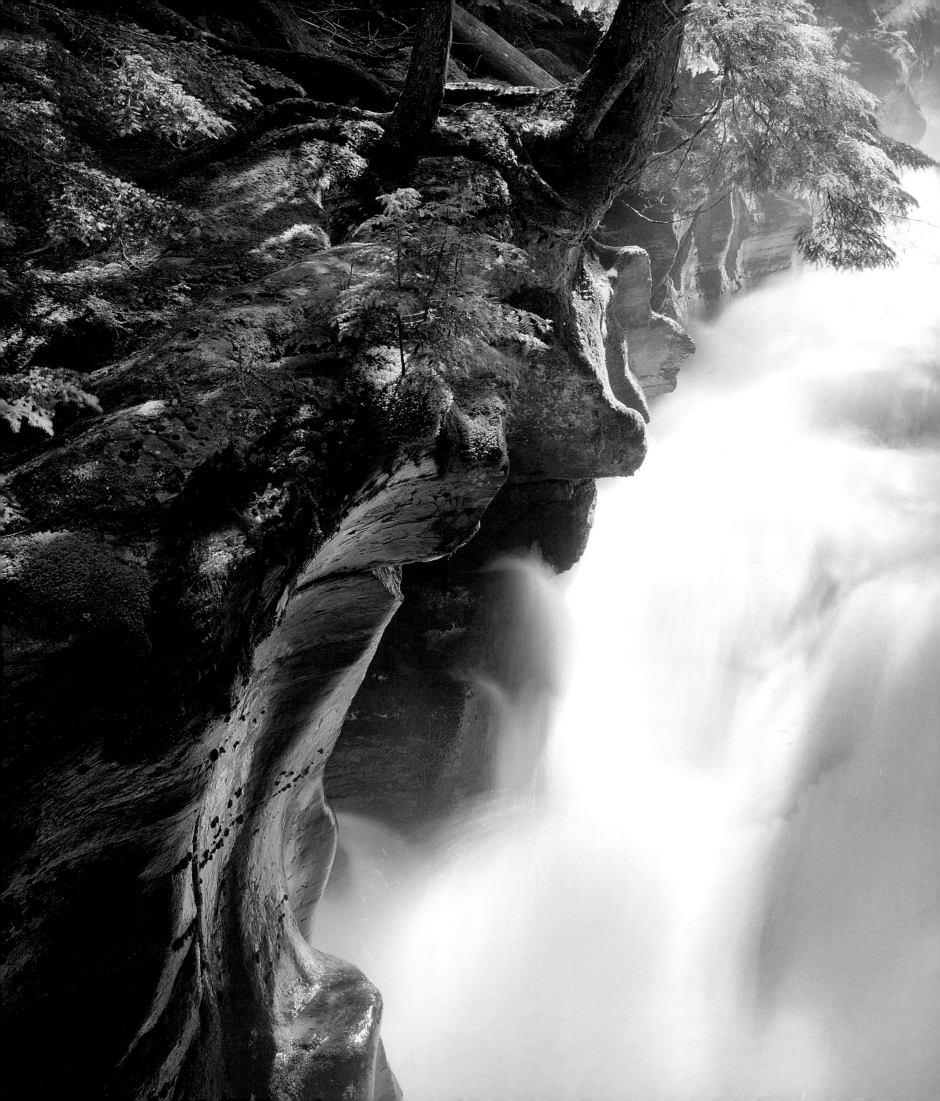

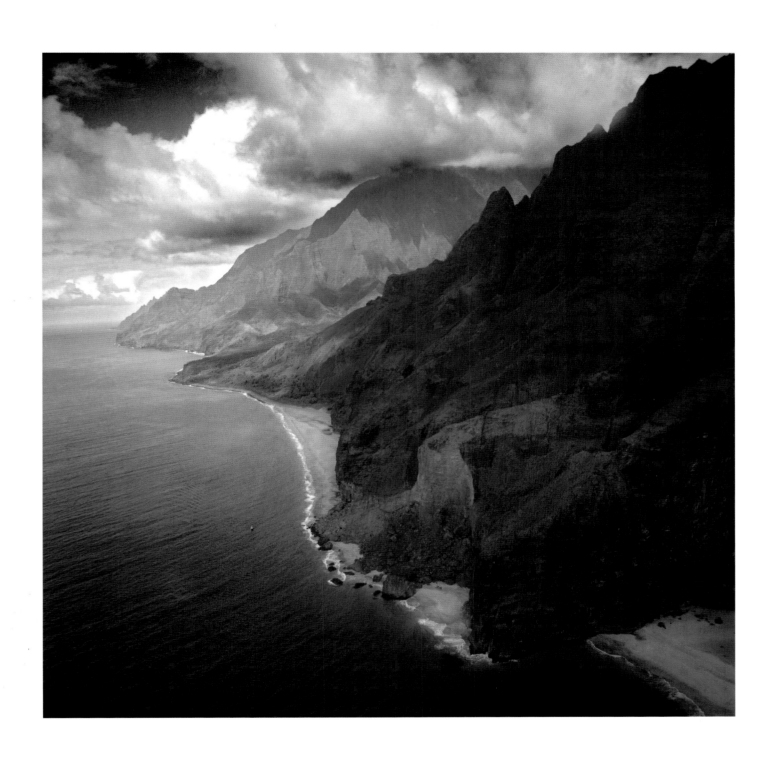

THE NAPALI COAST OF KAUAI, HAWAII, 1989

I'VE ALWAYS ENJOYED WORKING FROM A HELICOPTER AND TAKE ADVANTAGE OF
EVERY OPPORTUNITY TO DO SO. WE FLEW OVER MOST OF THE ISLAND THROUGH
RAIN ON THE DAY THIS IMAGE WAS MADE, BUT AS WE REACHED THE COAST, THERE
WAS A SHORT BREAK IN THE WEATHER.

FACING, AVALANCHE GORGE SCULPTURE, GLACIER NATIONAL PARK, MONTANA, 1992

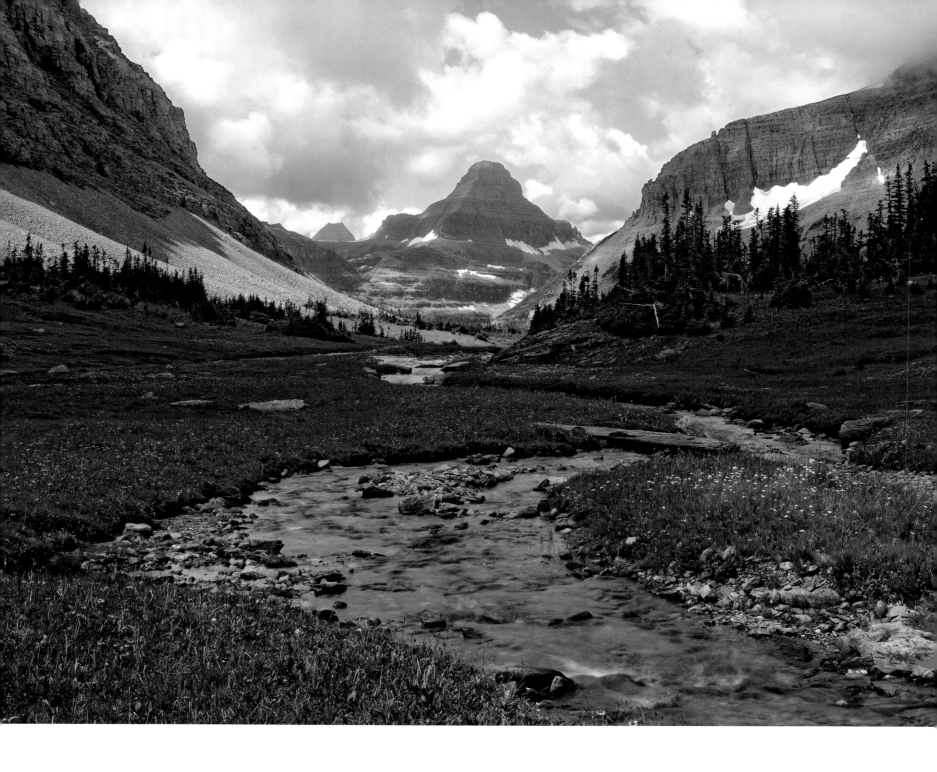

SIYEH WALK, GLACIER NATIONAL PARK, MONTANA, 1992

THE HIKE TO THIS POINT WAS SEVEN MILES ROUND-TRIP AND I DID IT TWICE ON SUCCESSIVE
DAYS. ON THE FIRST, I EXPOSED A BLACK AND WHITE IMAGE USING A RED FILTER OVER MY LENS TO
ACHIEVE A DARK SKY. WITHOUT THINKING, I THEN INSERTED A COLOR FILM HOLDER IN MY LARGE
FORMAT CAMERA AND EXPOSED TWO SHEETS. IT WAS NOT UNTIL I RETURNED TO THE TRAILHEAD
THAT I REALIZED I HAD NOT REMOVED THE RED FILTER BEFORE MAKING THE COLOR EXPOSURES.
DETERMINED TO MAKE A USABLE COLOR IMAGE, I RETURNED THE FOLLOWING MORNING AND
MADE THIS ONE. FORTUNATELY, THE WEATHER ON BOTH DAYS WAS COOPERATIVE, AND I'VE
RATIONALIZED THAT IT WAS EVEN BETTER ON THE SECOND DAY.

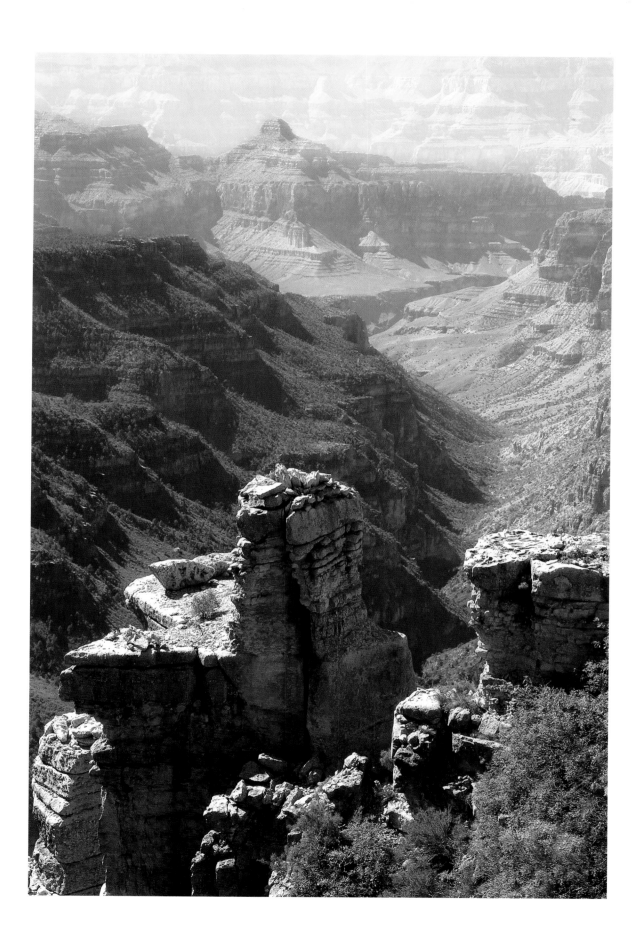

HALFWAY TO SUBLIME, GRAND CANYON NATIONAL PARK, ARIZONA, 2004

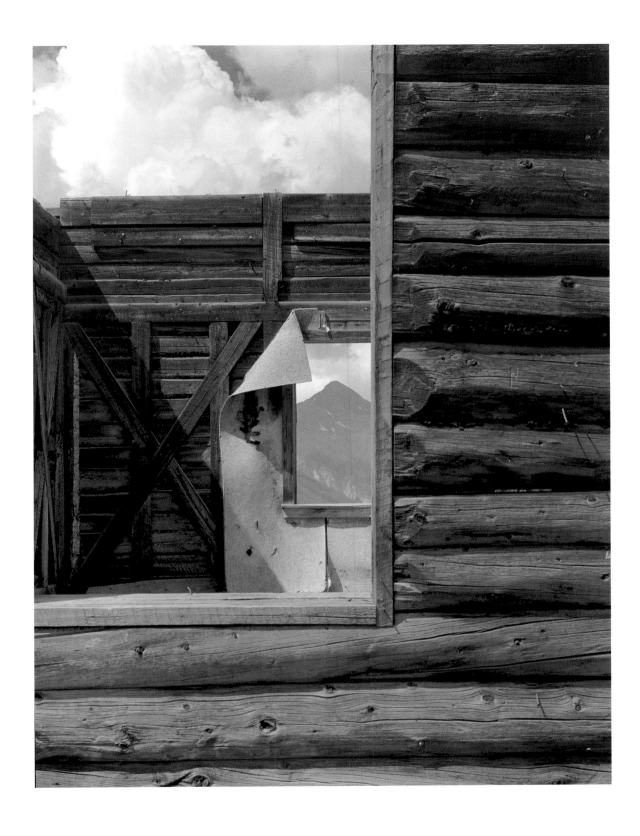

FROM TOM BOY RUINS, NEAR TELLURIDE, COLORADO, 1982

FACING, FROM MY WINDOW, MONTECITO, CALIFORNIA, 1989

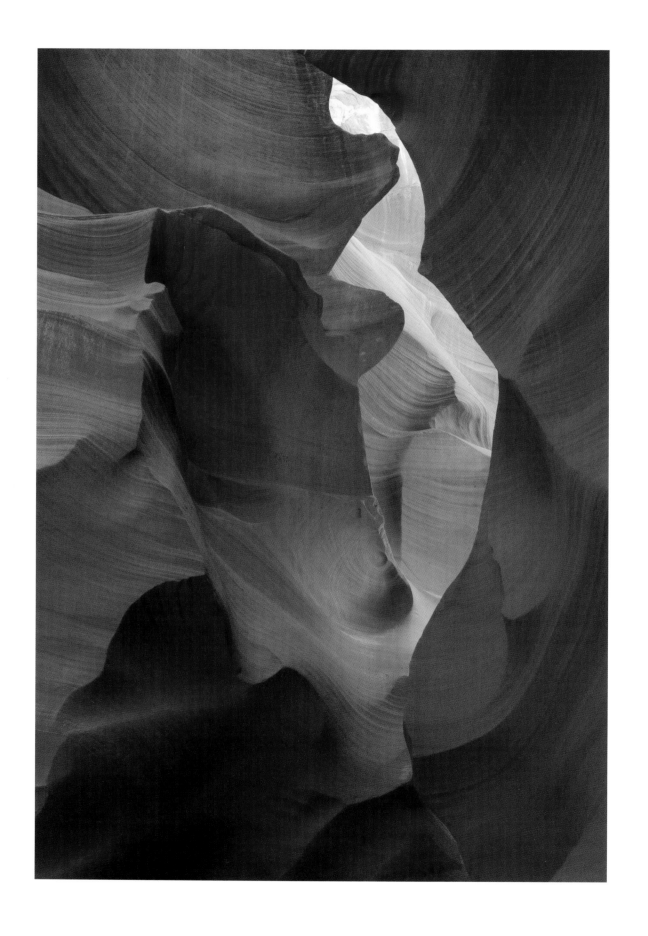

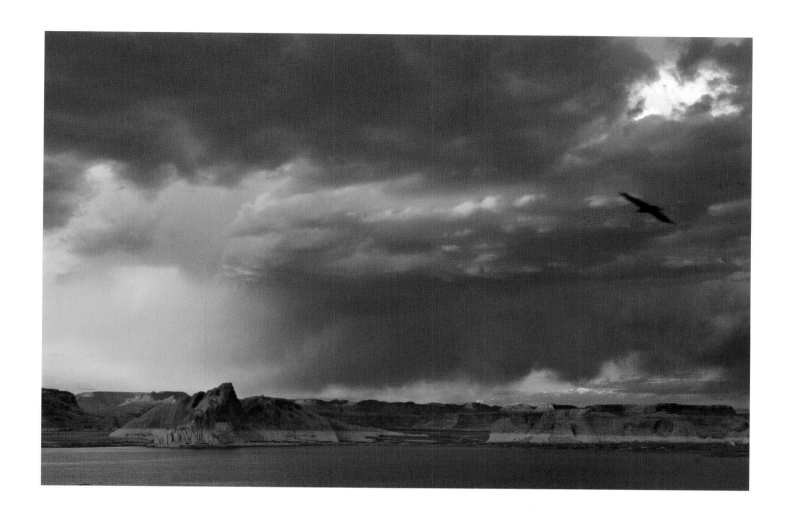

INTO THE SUNSET, LAKE POWELL, ARIZONA, 2004

FACING, IN LOWER ANTELOPE CANYON, ARIZONA, 2004

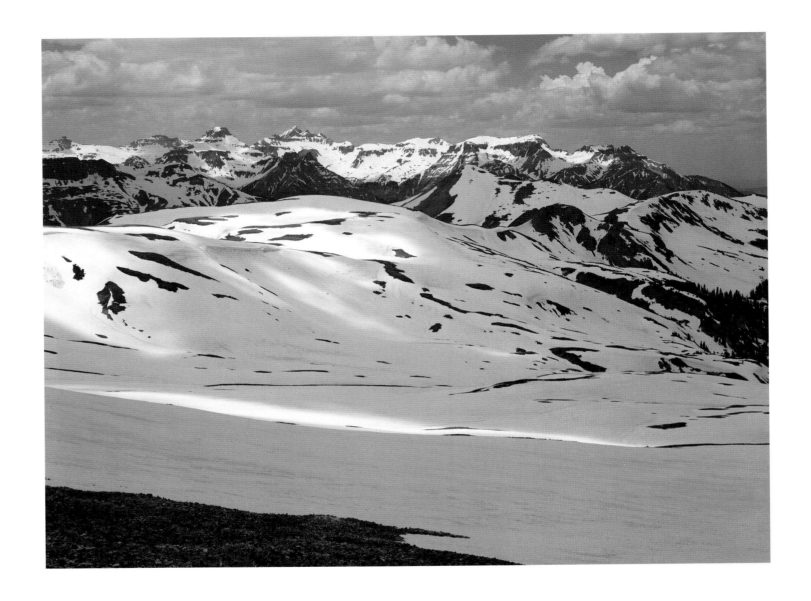

90

FROM ENGINEER'S PASS, SAN JUAN MOUNTAINS, COLORADO, 1992

FACING, BIG THOMPSON, LATE EVENING, ROCKY MOUNTAIN NATIONAL PARK, COLORADO, 1992

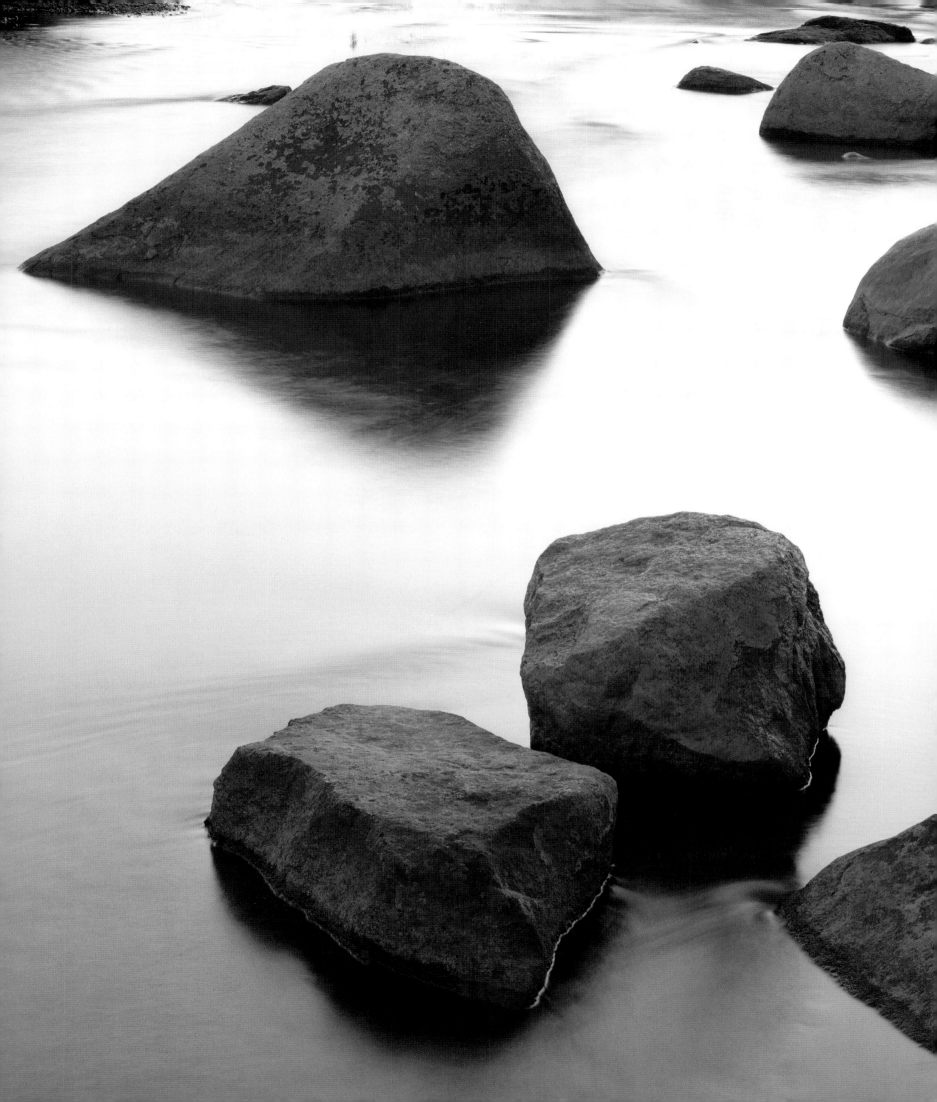

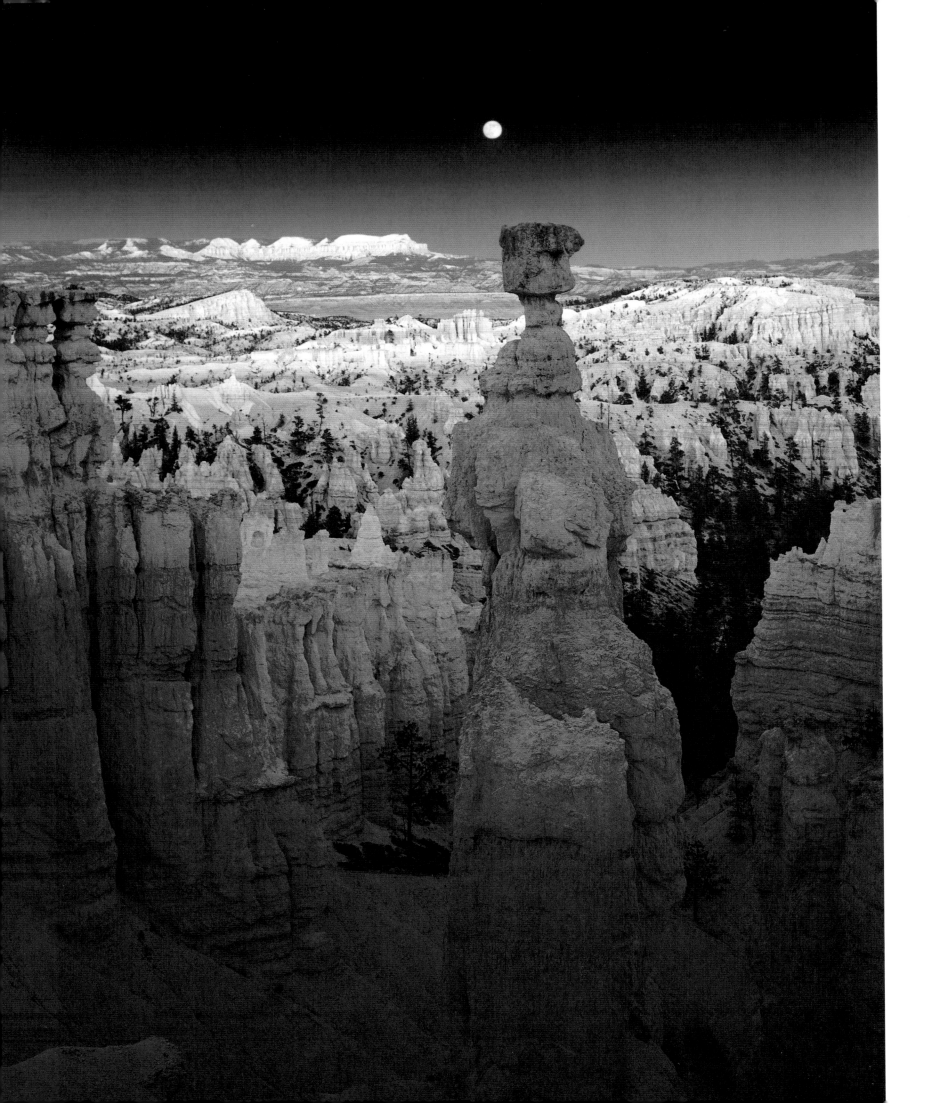

93

ELFIN WOOD, MONTECITO, CALIFORNIA, 1989

FACING, THOR'S HAMMER AT MOONRISE, BRYCE CANYON NATIONAL PARK, UTAH, 1989

FOG, FORD'S TERROR, ALASKA, 2002

FOCUSING ON THE LAND

LANDSCAPE PHOTOGRAPHY IS EVERYONE'S ART FORM. Apart from snapshots of friends and family, the first subjective images most of us ever made were pictures of our own back yards or scenes from vacations that we took as children.

Among other things, landscape photography is a form of relaxation, totally without pressure. Of all the approaches one can take to the medium, it is the least intrusive, the least interactive in a personal sense, and thus the least threatening. Landscape photography, in one sense, can be called a relatively safe practice, but it also can be frustrating, for while you are not likely to receive harsh criticism[15] for your landscape images, neither are you likely to garner critical acclaim or even faint praise from your peers for them. A landscape, after all, competes with the reality, memory and every picture of a similar subject that resides in someone's photo album or hangs in a gallery or museum.

Eavesdropping on the comments of an opening night audience at an exhibition of contemporary landscape images, one hears comments like, "I have a photograph that I made from this exact point when we were there on our honeymoon." Or, "This is nice, but you should see that view at sunset." Or, "My twelve-year-old son is studying photography in school and he just made a

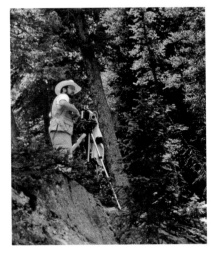

PHOTO BY CLIFF BROWN

REDWOODS, SONOMA COUNTY, CALIFORNIA, 1997

photograph exactly like that." Or, my personal all-time favorite, "I don't know why he shot that in black and white; it would be just great in color."

In a society inundated with images, the challenges to a contemporary landscape photographer are not easily met. Creating images with enough power to arrest a viewer's attention requires a distinctive combination of vision, style and statement.

COBBLESTONE BRIDGE, ACADIA NATIONAL PARK, MAINE, 1994

FACING, FOREST ROAD, GLACIER NATIONAL PARK, MONTANA, 1990

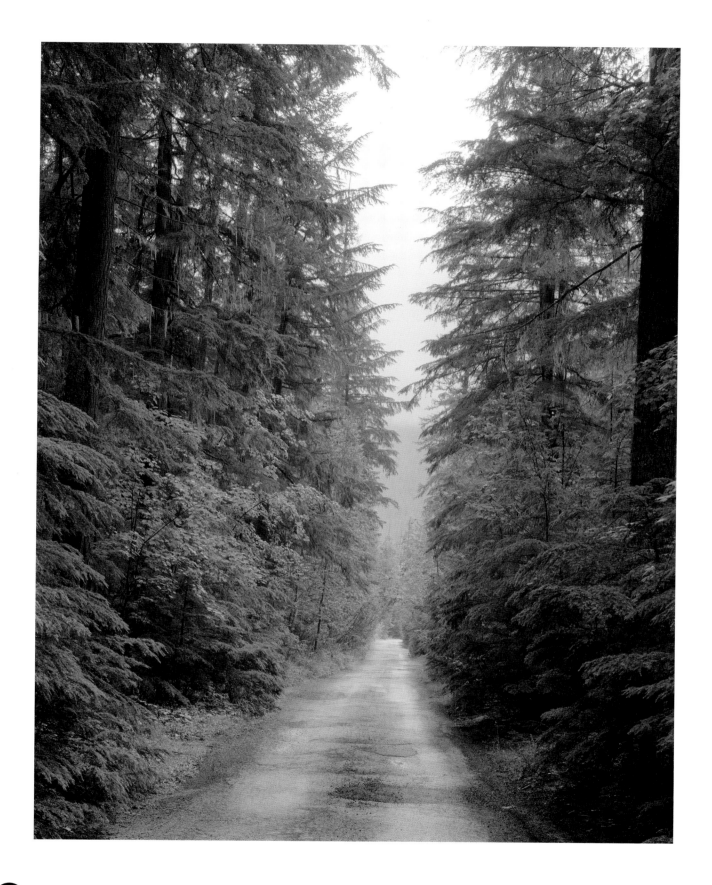

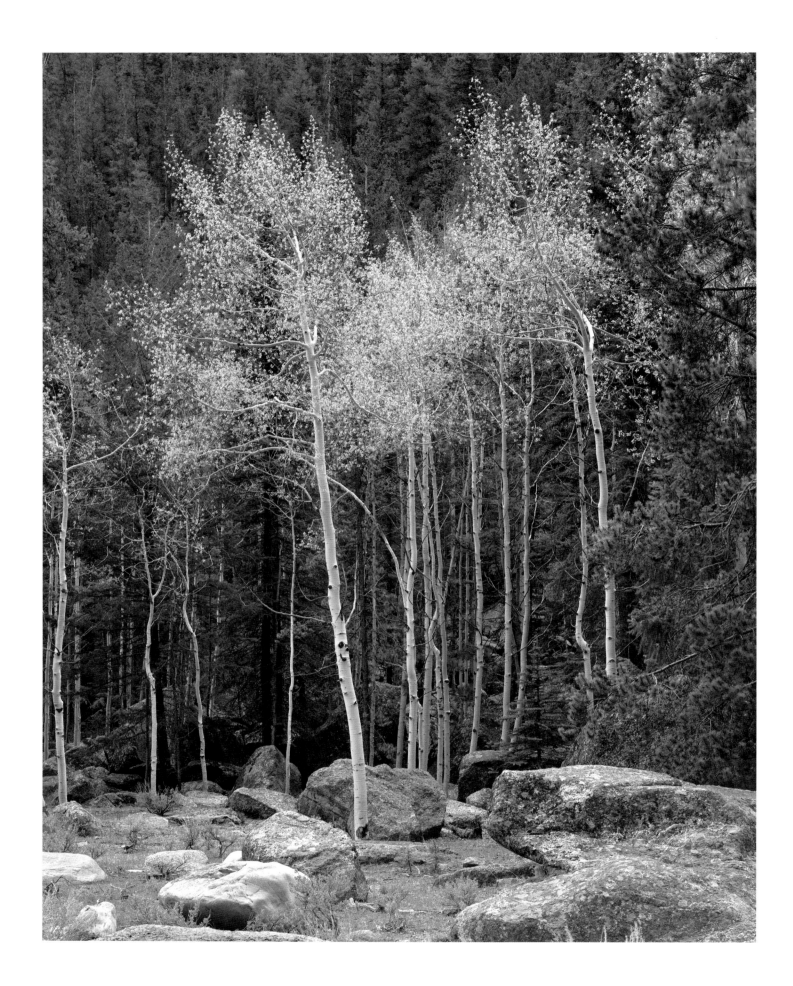

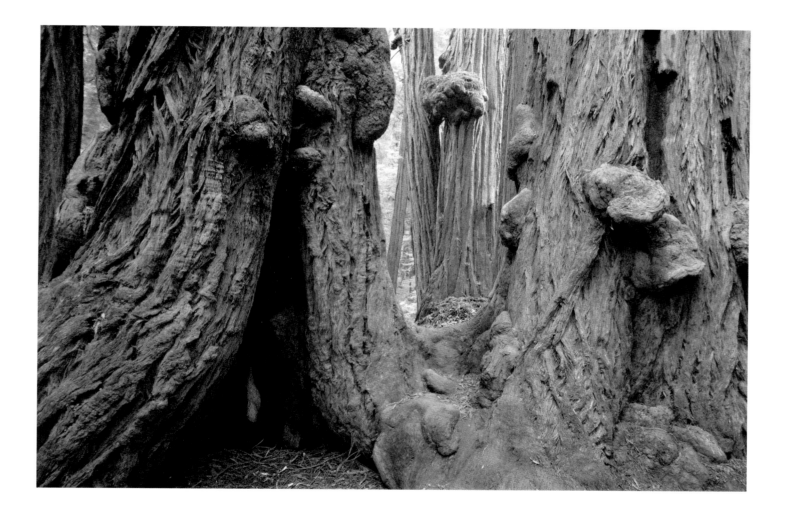

REDWOOD BURLS, MUIR WOODS, CALIFORNIA, 2005

FACING, SPRING ASPENS, NEAR ALMONT, COLORADO, 1982

TRAILSIDE COLOR, ROCKY MOUNTAIN NATIONAL PARK, COLORADO, 1985

A love for making photographs is not, by itself, sufficient reason to make photography one's life's work. Some deeper grounding motive is necessary to support a sustained effort to survive financially and thrive philosophically. For me this motive was concern for the natural environment. Fortunately, work as a commercial photographer provided the resources to make personal images.

I never recognized the dichotomy of commercial photography and photographic "Art." To be sure, a difference exists between them, but I don't perceive a methodological contradiction. Both can be approached with concern for technical quality, design, clarity of communication, and an attempt to reflect personal vision or expression. I was not always successful in every respect in commercial work; neither am I always successful in my personal work.

When you make images to satisfy a desire for personal expression, you can hide your failures from public view. Commercial photographers, on the other hand, must produce images that satisfy the requirements of their assignments whether or not they achieve personal expectations. While personal images are created to achieve the photographer's own objectives and commercial objectives are assigned by clients, client objectives do not have to dictate style, and there is always the possibility of a successful partnership between client and photographer.

Every photograph makes a statement. Some make strong statements that leave lasting impressions. Some photographers have made statements that changed society. Lewis Hine exposed the exploitation of child labor by American industry during the first decade of the twentieth century and helped stir the conscience of the nation. William Henry Jackson's images of the Yellowstone area of Wyoming spurred Congress to establish our first national park. Edward Sheriff Curtis showed the dignity of Native Americans and dispelled the image of primitive savages.

When we rise above the early impulse to simply record things in our pictures, we begin to make statements. It may start with an interest in the quality of light, the establishment of mood, the search for an unusual perspective, or a desire to relate the objects of our visual interest to one another. We are saying to the viewer, "Have you ever seen it this way?" or "Look how interesting this subject is."

I became aware of the statement my images were making as I discovered how the subjects of my photographs changed with the passage of years. The pictures showed me changes that occur in nature—not only as a result of human exploitation but as a consequence of natural phenomena. No subject is forever. I wanted to share through photographs the natural wonders that mean so much to me, the sense of awe that they evoke, their serenity, their majesty, their drama, so that others might come to care about them in a similar way. I knew I wasn't the first photographer to devote myself to that purpose, but I decided there were new subjects that needed to be shown and a personal vision that could distinguish me from other landscape and nature photographers.

Of course, I want my photographs appreciated as art. That is necessary to achieve the broader objective, which I've been told by some is unrealistic. I am content, however, to let the images speak for themselves and to one by one find receptive audiences. How many people we influence seems less important than who is influenced. As Aldo Leopold said, "We shall never achieve harmony with land, any more than we shall achieve absolute justice or liberty for people. In these higher aspirations the important thing is not to achieve, but to strive."[16]

STAGHORN FERN, SAN ANTONIO, TEXAS, 2000

107

108

CLOUDS OVER TALLGRASS PRAIRIE, OKLAHOMA, CA. 1985

FACING, PEACEFUL MORNING, ALASKA, 2002

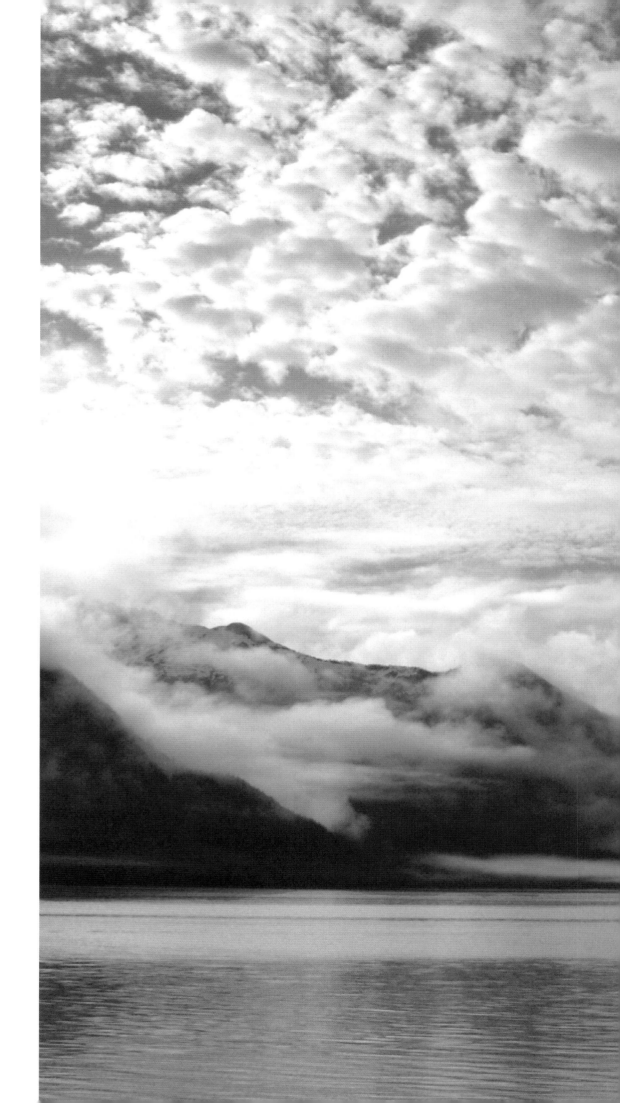

MORNING AT THOMAS BAY, ALASKA, 2002

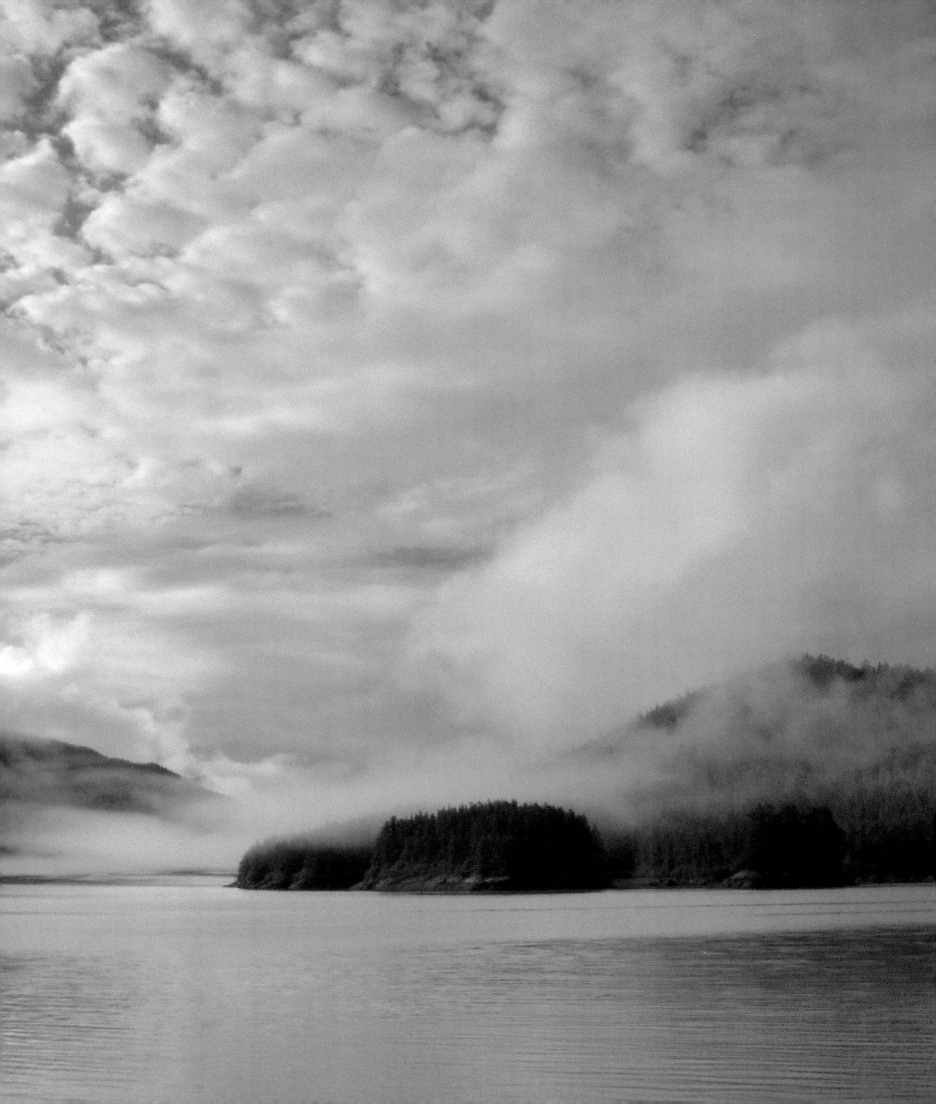

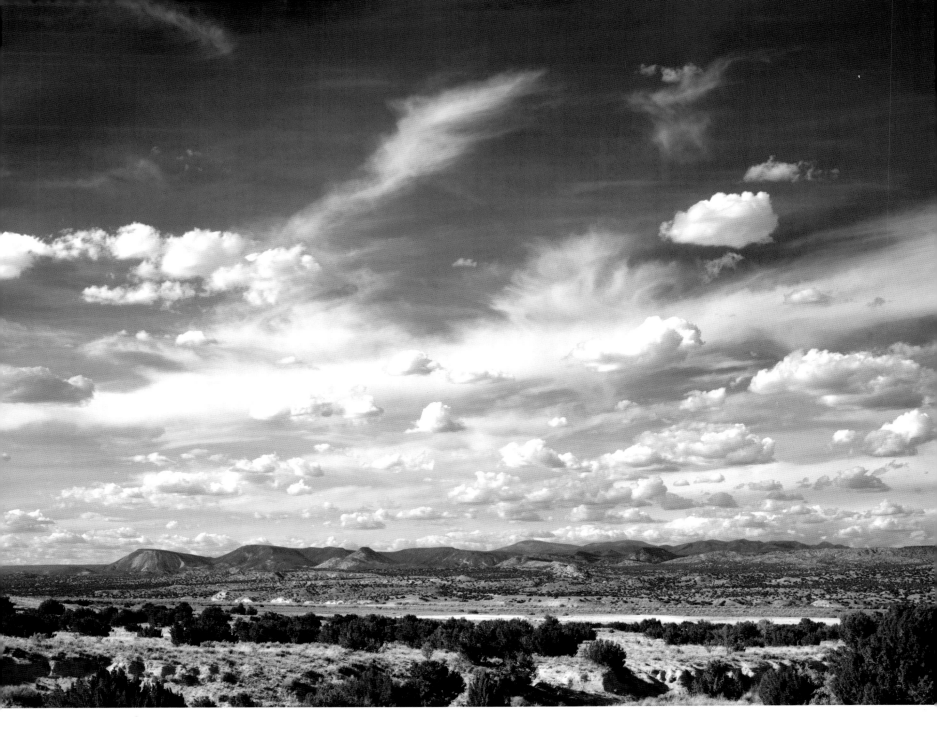

112

NEW MEXICO SKY, NEAR ALBUQUERQUE, 1997

FACING, THUNDERHEADS, LONG'S PEAK, ROCKY MOUNTAIN NATIONAL PARK, COLORADO, 1986

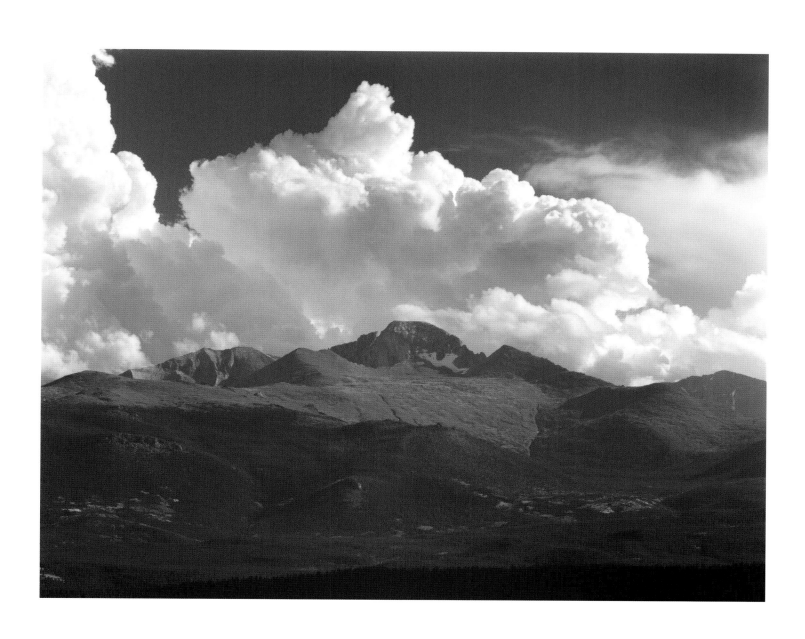

NEEDLE ROCK, HOTCHKISS, COLORADO, 1982

FACING, SPECIMEN MOUNTAIN, CLOUDS, ROCKY MOUNTAIN NATIONAL PARK, COLORADO, 1985

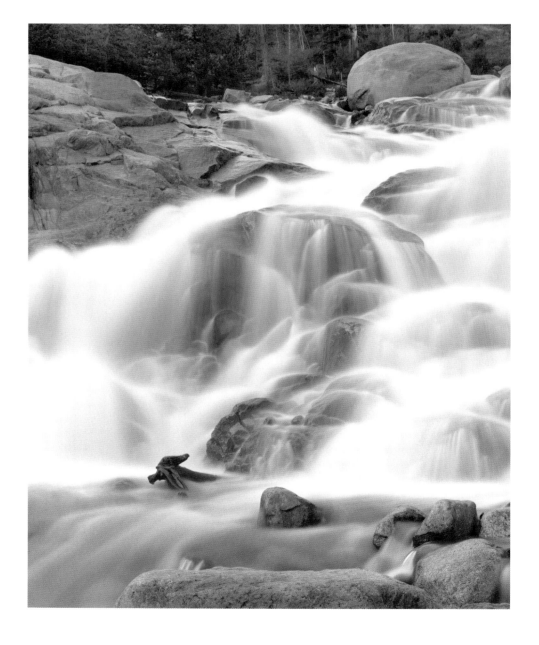

HORSESHOE FALLS, ROCKY MOUNTAIN NATIONAL PARK, COLORADO, 1999

FACING, ANGRY SONOMA SURF, CALIFORNIA, 1986

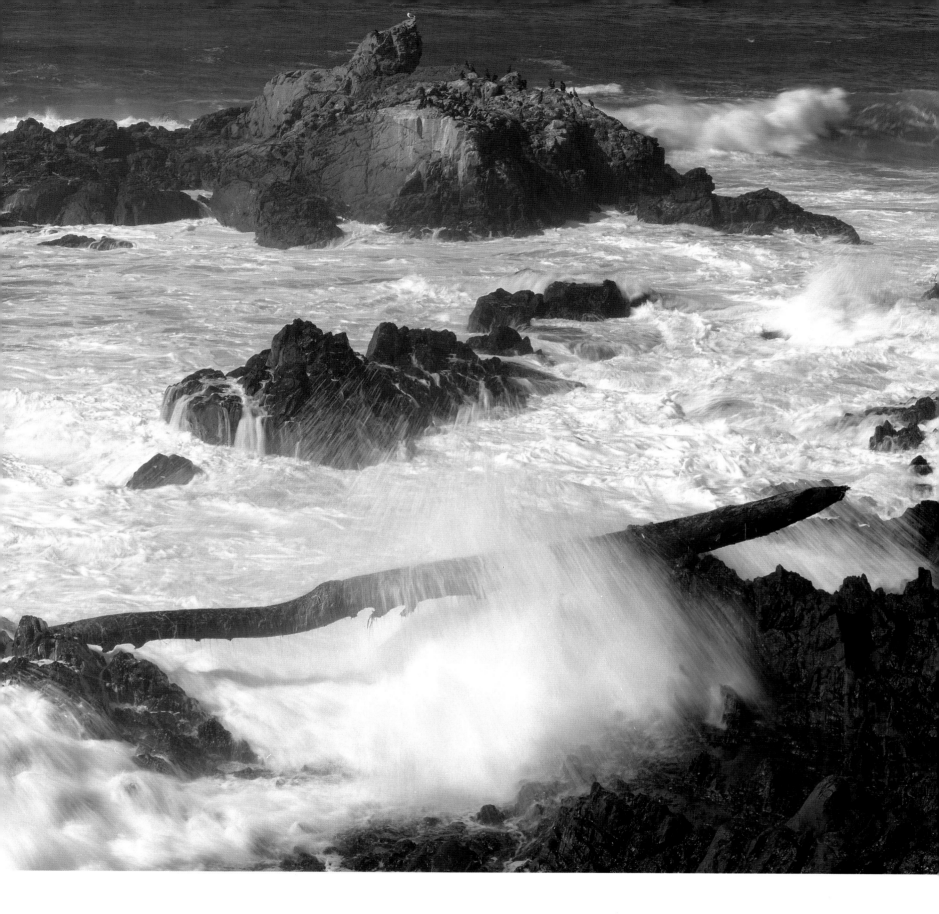

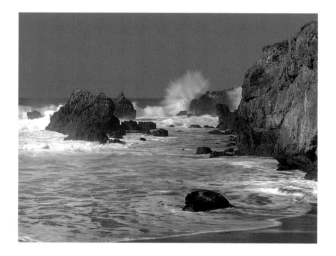

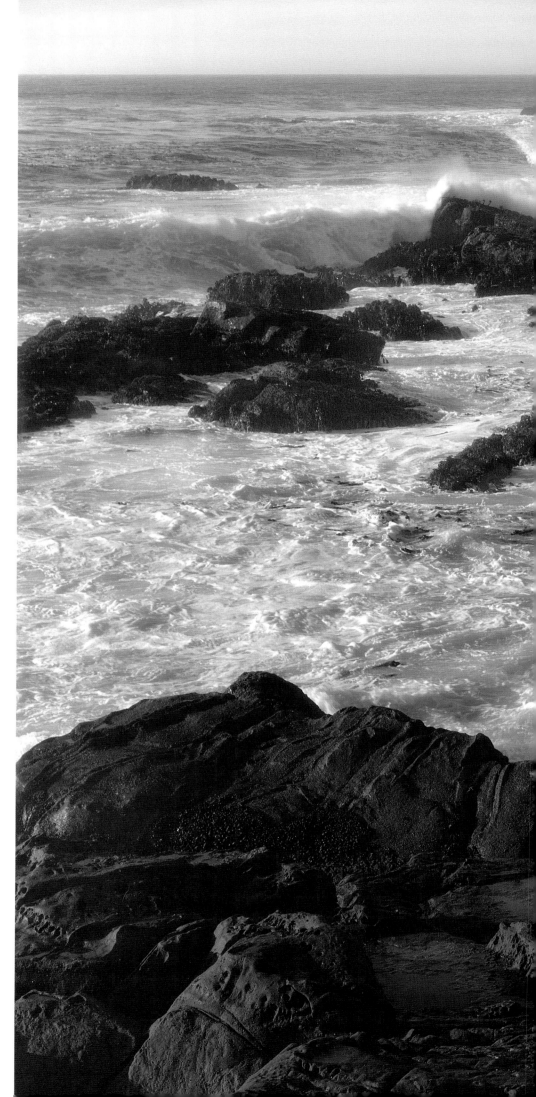

SONOMA WAVE, CALIFORNIA, 1985

FACING, AT STEWARTS POINT, CALIFORNIA, 1986

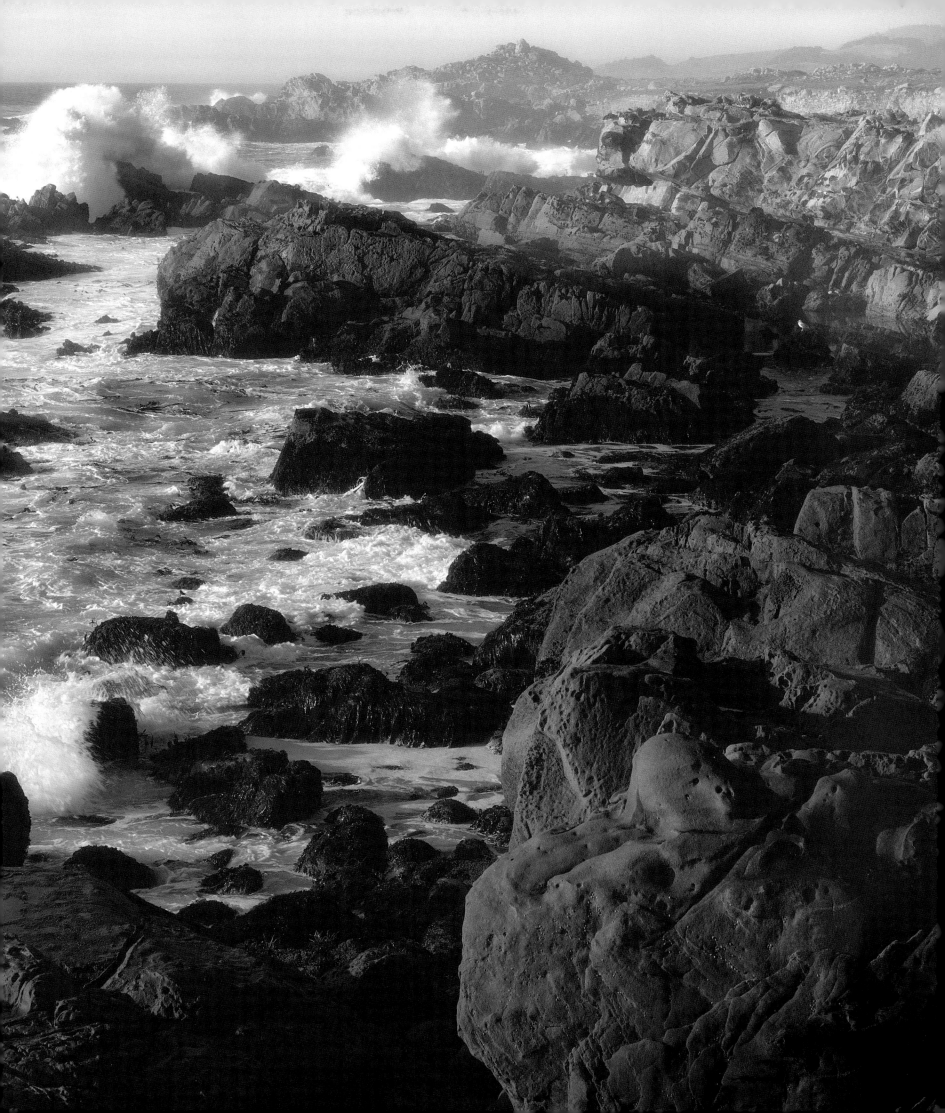

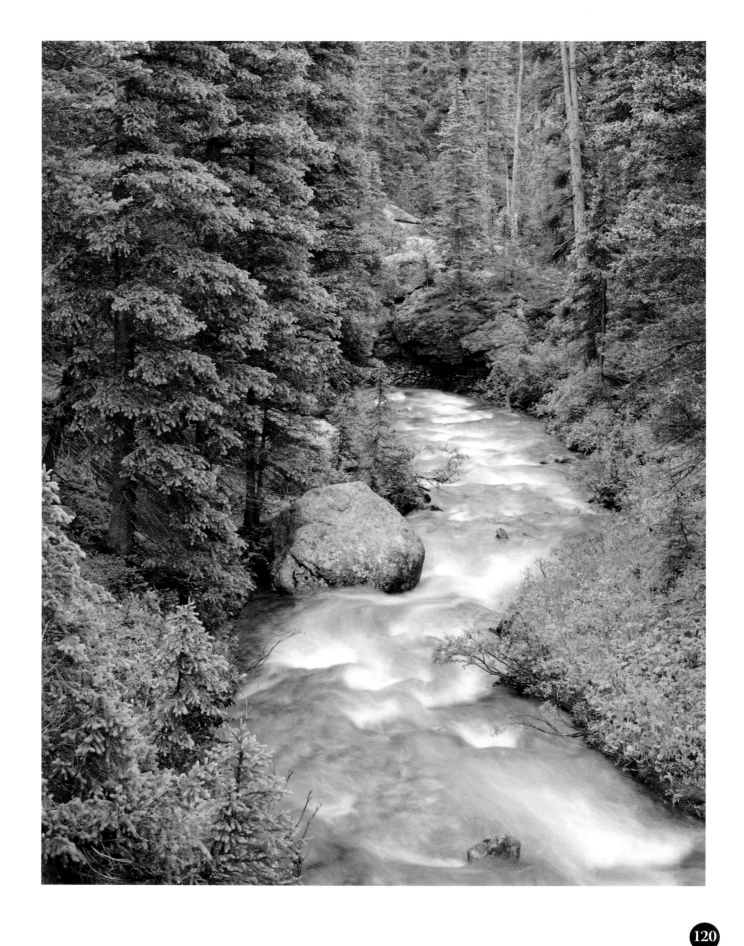

PAHOEHOE LAVA, CRATERS OF THE MOON NATIONAL MONUMENT, IDAHO, 1972

FACING, FALL RIVER, ROCKY MOUNTAIN NATIONAL PARK, 1984

I'M FREQUENTLY ASKED IF I HAVE FAVORITE PLACES. THIS CERTAINLY IS ONE OF
THEM. I GO THERE EVERY TIME I VISIT "ROCKY" AND FREQUENTLY SHARE IT WITH
WORKSHOP PARTICIPANTS.

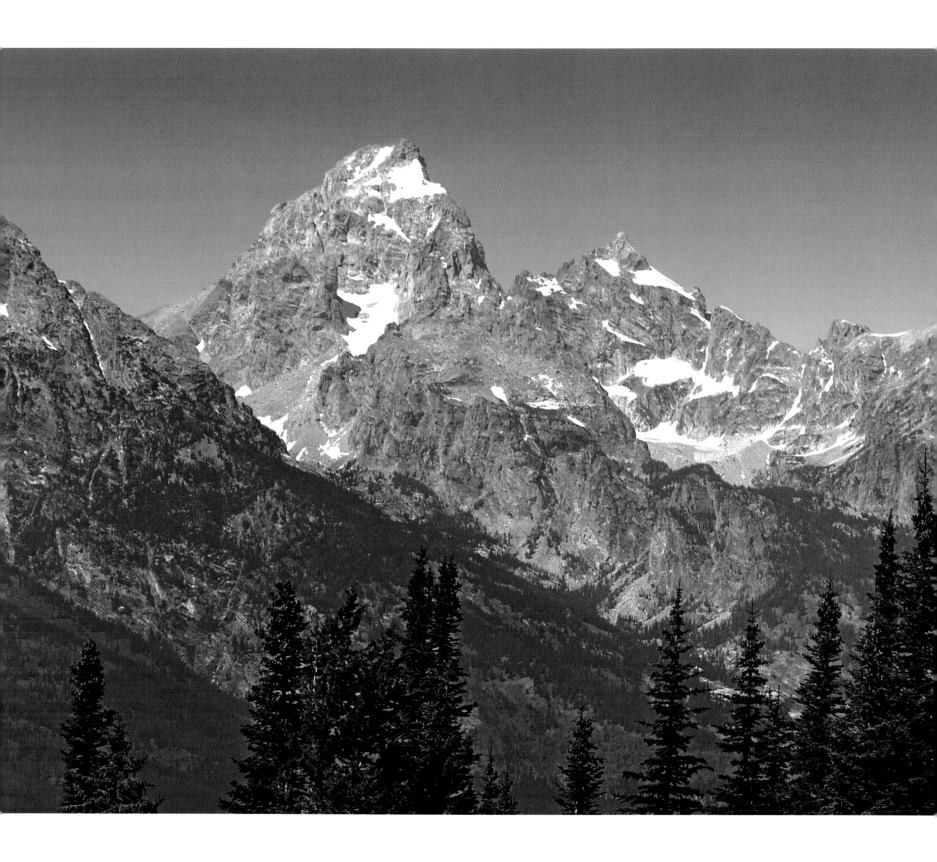

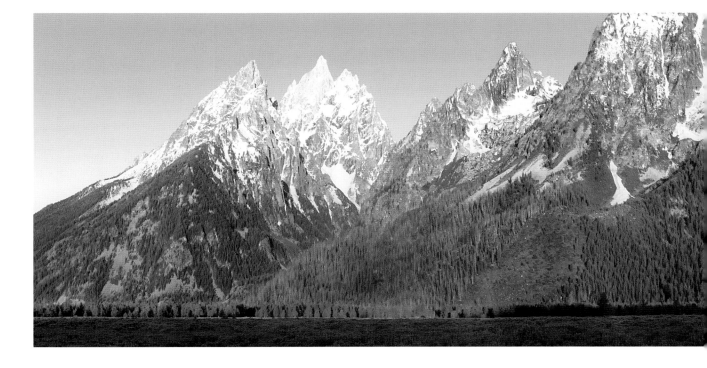

MORNING IN THE GRAND TETONS, 2005

FACING, THE GRAND TETON FROM BLACKTAIL BUTTE, WYOMING, 1970

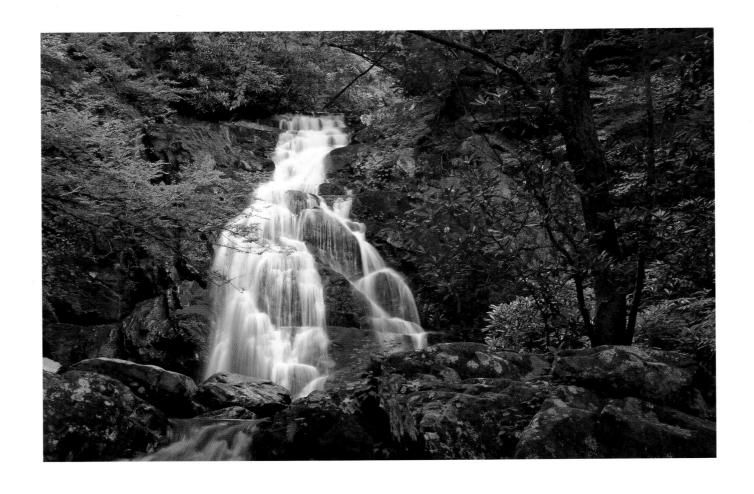

SPRUCE CREEK FALLS, GREAT SMOKY MOUNTAINS NATIONAL PARK, TENNESSEE, 2004

FACING, WILDFLOWERS, PRESTON PARK, GLACIER NATIONAL PARK, MONTANA, 1990

I WOULD NEVER HAVE FOUND THIS PLACE WITHOUT DAVE AND MARTHA THOMAS
TO GUIDE ME. IT IS VERY SPECIAL AND DELICATE. WORK CAREFULLY, FOR IT IS
IMPOSSIBLE TO WALK HERE WITHOUT DESTROYING PLANT LIFE.

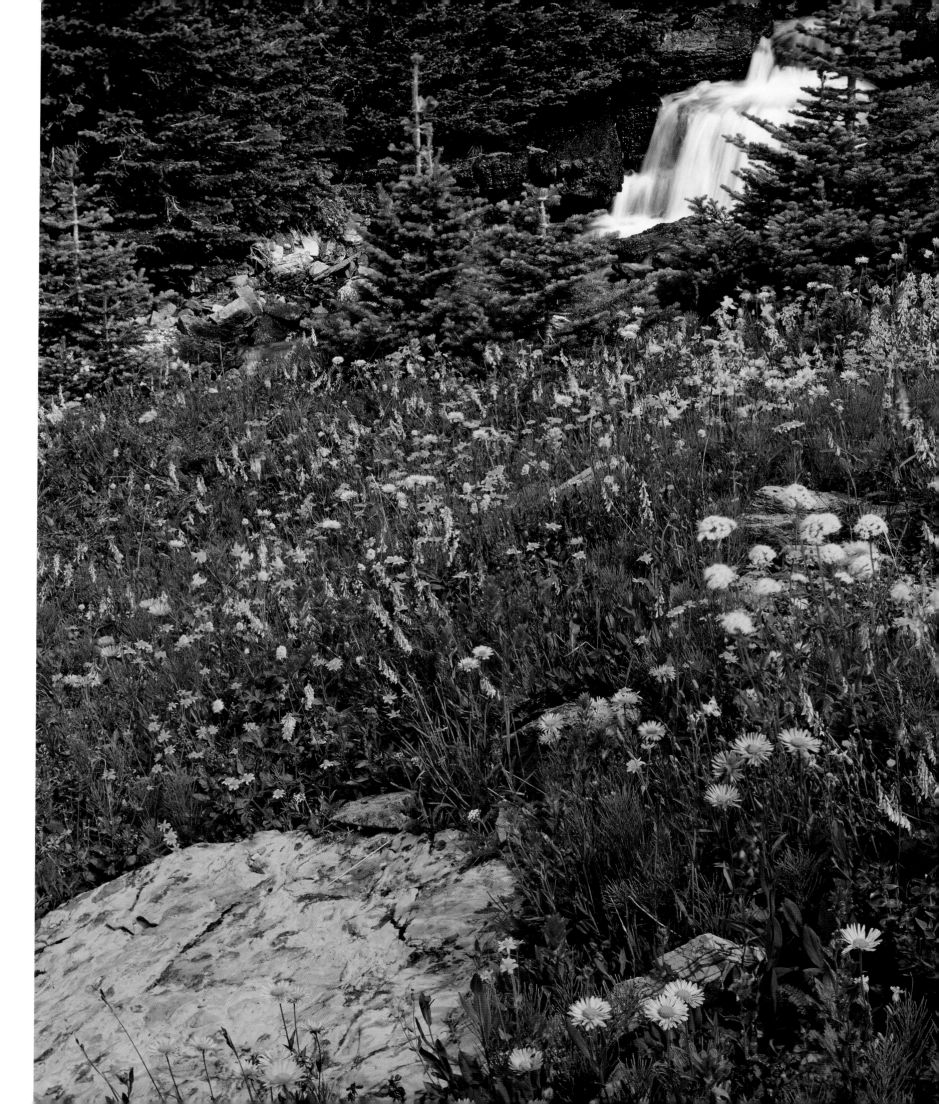

GROUND COLOR, ACADIA NATIONAL PARK, MAINE, 2001

When I began work on this book, I made a list of the natural places I've photographed since 1952—fifty-nine National Park Service sites, five Bureau of Land Management areas, and seven National Wildlife Refuges. I did not attempt to count the National Forests where I've hiked and camped.

I'm almost ashamed to admit it, but I never visited Great Smoky Mountain National Park or Reelfoot Lake during the years I spent living and growing up in Tennessee. I came back to these places much later, perhaps with a greater appreciation of their value.

My first photographs in national parks were made at some of the icons of the National Park Service, Yellowstone and the Grand Canyon, and since then I have ranged from the Everglades in Florida to Mount Rainier in Washington and from Death Valley in California to Acadia in Maine. Most of my images have been made in locations west of the Mississippi and I have explored the continental divide from Arizona through Montana.

In 1984, I had the very good fortune to be invited to serve as the second artist-in-residence at Rocky Mountain National Park in Colorado. The program was created following the restoration of an historic cabin in Rocky's Moraine Park area, which had been a summer retreat of journalist William Allen White[17] and his family for thirty years. The University of Kansas, home of the William Allen White School of Journalism and Mass Communications, provided funds to restore the cabin. The first person to stay in it after its renovation was the dean of the school, Del Brinkman. My stay followed his and became the first of eleven National Park Service artist-in-residence positions in five parks that I've held over the years since, four of them in Rocky.

BACKYARD COLOR, TULSA, OKLAHOMA 2004

These A-I-R programs, now offered by several parks throughout the nation, are volunteer positions that allow professional artists a chance to live in a park for a prescribed period during which they are encouraged to create their own work and interpret the park through their media. Over the years, the programs have hosted visual artists working in two- and three-dimensional media, writers, storytellers, musicians and performance artists. In exchange for the privilege, the artists agree to donate at least one example of work created as a result of their experience, interact with the public as the individual park deems it appropriate, and permit the use of donated work for educational and interpretive purposes. The extraordinary value of these opportunities cannot be overstated, for they have given public exposure to my work, enabled me to expand my portfolio, broadened my understanding of the parks and their history, allowed me to experience natural events in ways an average park visitor can only imagine and introduced me to remarkable, dedicated and talented people with whom I've developed lasting friendships.

The concept of national parks is a uniquely American contribution to the world. Our parks are a legacy we cherish and protect for future generations even as we enjoy them ourselves. These are places I never have taken for granted and in which, as a member of the society that established them, I take a proprietary interest. "Take nothing but pictures; leave nothing but footprints" is to me a mantra to be shared with every student.

The parks are are what is left of the wilderness "…out of which we have hammered America."[18] We go there to recall our beginnings and to find the restorative qualities that can keep us sane in a world which so often seems mad and irrational. I believe our obligation to these lands and the life they support is no less than our obligation toward our cities and the people within them.

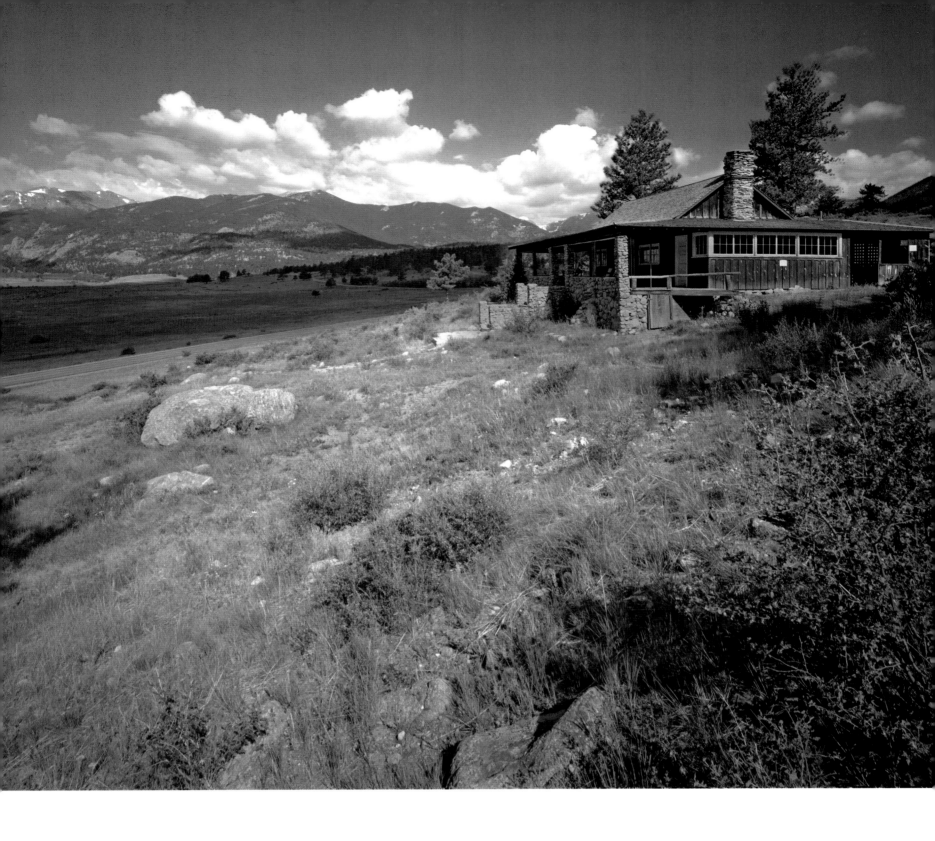

THE WILLIAM ALLEN WHITE CABIN, ROCKY MOUNTAIN NATIONAL PARK, COLORADO, 1985

THIS IS "HOME" TO ROCKY MOUNTAIN NATIONAL PARK'S ARTISTS-IN-RESIDENCE. I WAS
PRIVILEGED TO USE IT ON THREE OCCASIONS. BECAUSE IT IS NOT WINTERIZED, I COULD NOT
USE IT DURING MY WINTERTIME VISIT IN 1987.

130

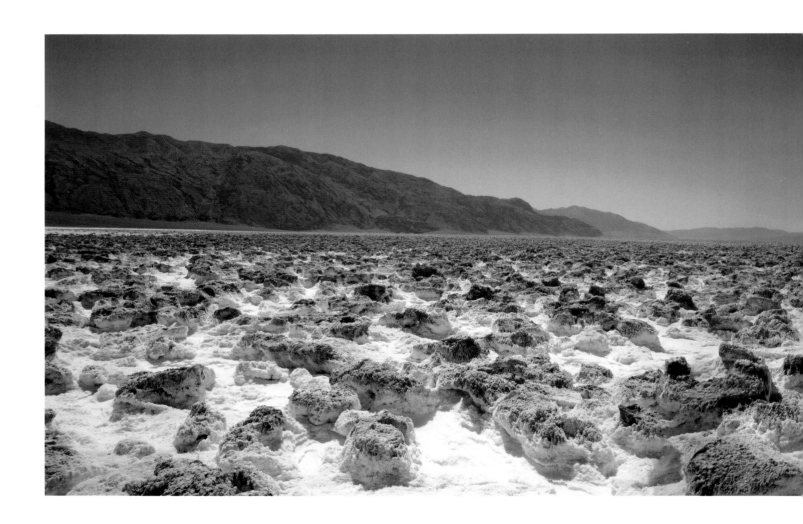

132

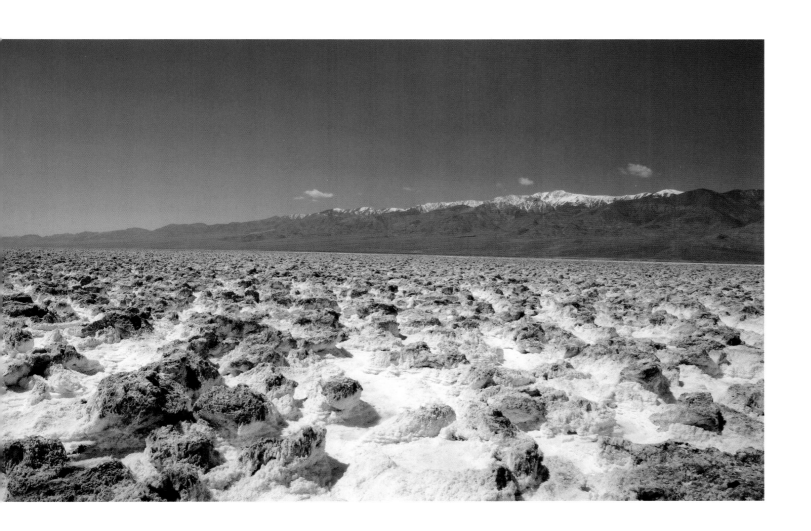

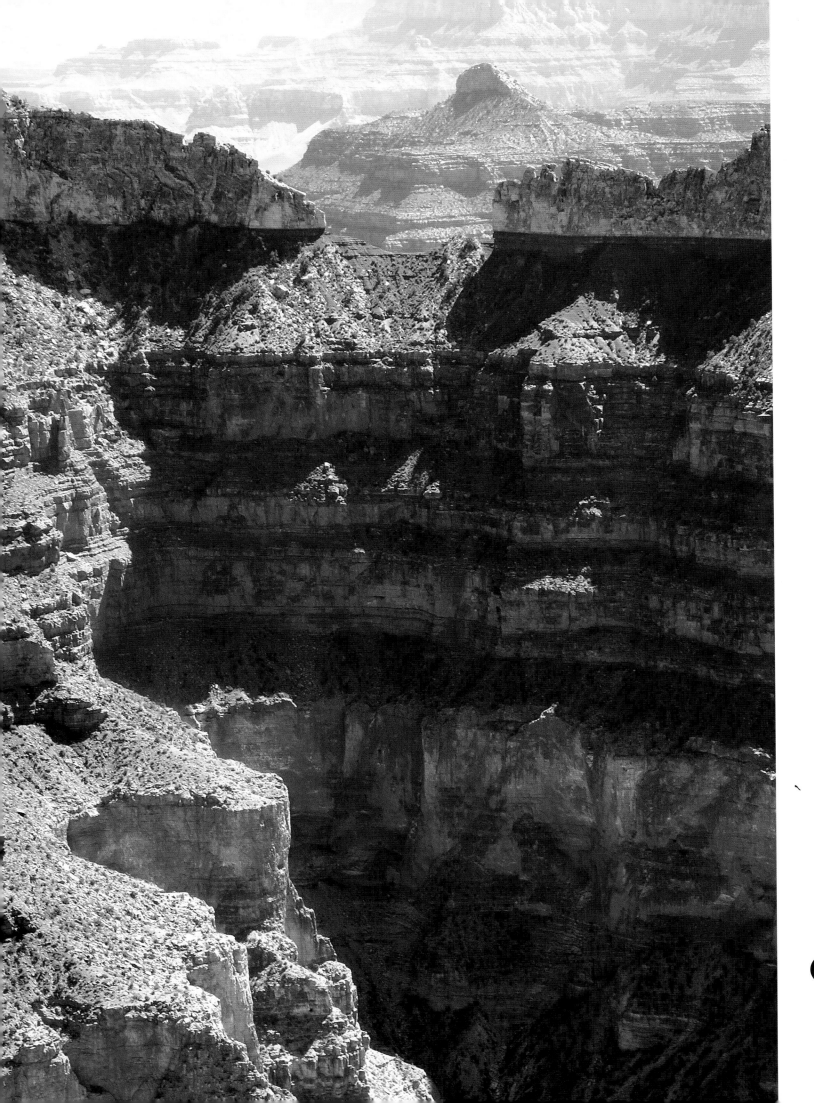

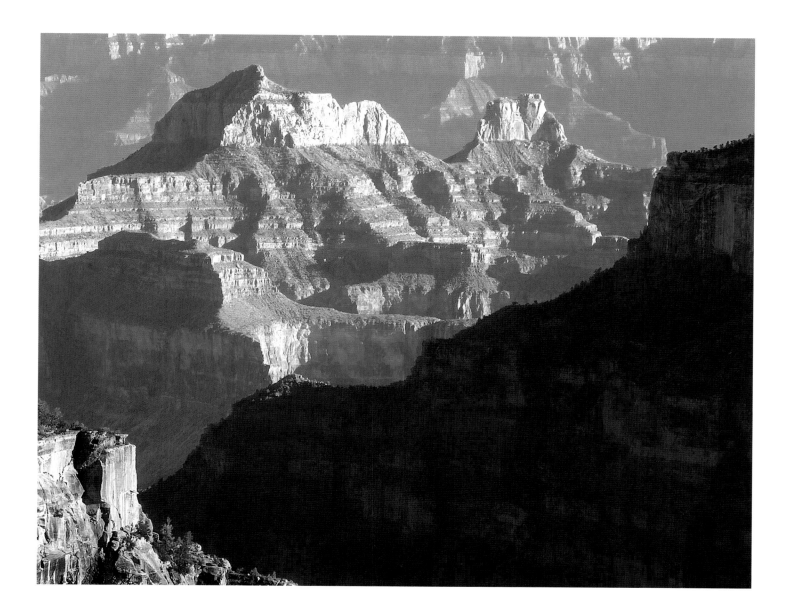

FROM WIDFORSS POINT, GRAND CANYON NATIONAL PARK, ARIZONA, 2004

BECAUSE OF ITS ENORMITY, THE GRAND CANYON IS ESPECIALLY DIFFICULT TO PORTRAY IN
PROPORTION TO THE ACTUAL EXPERIENCE. DISTANCES PLAY TRICKS ON ONE'S PERCEPTIONS. IT
TOOK ME MANY VISITS OVER FIFTY YEARS TO COMPREHEND THE ISSUES, WHICH ARE ALL ABOUT
TONAL VALUES.

IN MOST LANDSCAPE PHOTOGRAPHS, THE PHOTOGRAPHER RELIES ON THE FADING VALUES
OF BACKGROUND FORMATIONS, IN CONTRAST WITH THE CLEAR BOLD SHADES OF THE FOREGROUND,
TO CONVEY A SENSE OF DEPTH OR DISTANCE. WE RECOGNIZE THAT WHEN MOUNTAINS APPEAR
PALE ON THE HORIZON AND LACKING IN CONTRAST WITH THE SKY ABOVE, WE SENSE THAT THOSE
PEAKS ARE FAR AWAY. BUT WHEN WE STAND ON THE NORTH RIM OF THE GRAND CANYON ON A
CLEAR DAY AND LOOK TOWARD THE SOUTH RIM, THE DISTANCES—GREAT AS THEY ARE—DO NOT
IMPART TO OUR PHOTOGRAPHS THE DESIRED IMPRESSION OF THE CANYON'S BREADTH. THE FADING
HORIZON IS STILL FARTHER SOUTH, WELL BEYOND THE CANYON'S RIM.

PAINTERS LIKE THOMAS MORAN WERE WELL AWARE OF THIS AND EXPRESSED THEIR OWN
PERCEPTIONS THROUGH A CAREFULLY ADJUSTED PALETTE.

FACING, LOOKING EAST FROM POINT SUBLIME, GRAND CANYON NATIONAL PARK, ARIZONA, 2004

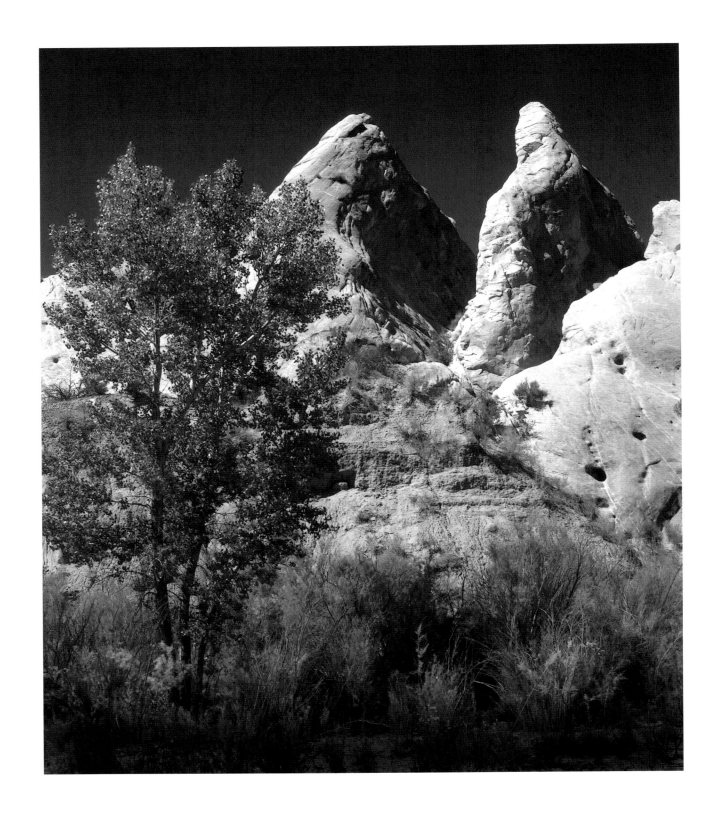

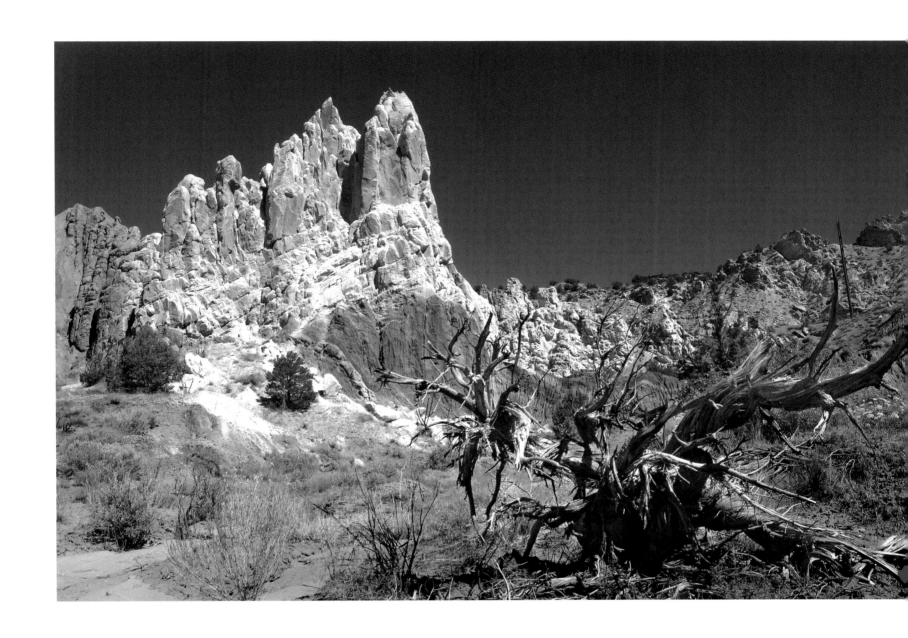

ABOVE AND FACING, COTTONWOOD CANYON, UTAH, 2004

BETWEEN HIGHWAY 89 A FEW MILES WEST OF PAGE, ARIZONA, AND TROPIC, UTAH, IS THE STRANGE AND WONDERFUL COTTONWOOD CANYON ROAD WHICH PROVIDES ACCESS TO MANY DIVERSE GEOLOGIC FEATURES IN COLORS RANGING FROM VIVID RED TO PURPLE, GREEN AND YELLOW. EXCEPT DURING EXTREMELY DRY PERIODS, IT IS VERY RISKY TO TRY IT WITHOUT A FOUR-WHEEL DRIVE VEHICLE AND PLENTY OF GROUND CLEARANCE, AND, EVEN THEN, IT'S A GOOD IDEA TO TAKE A SHOVEL, JUST IN CASE.

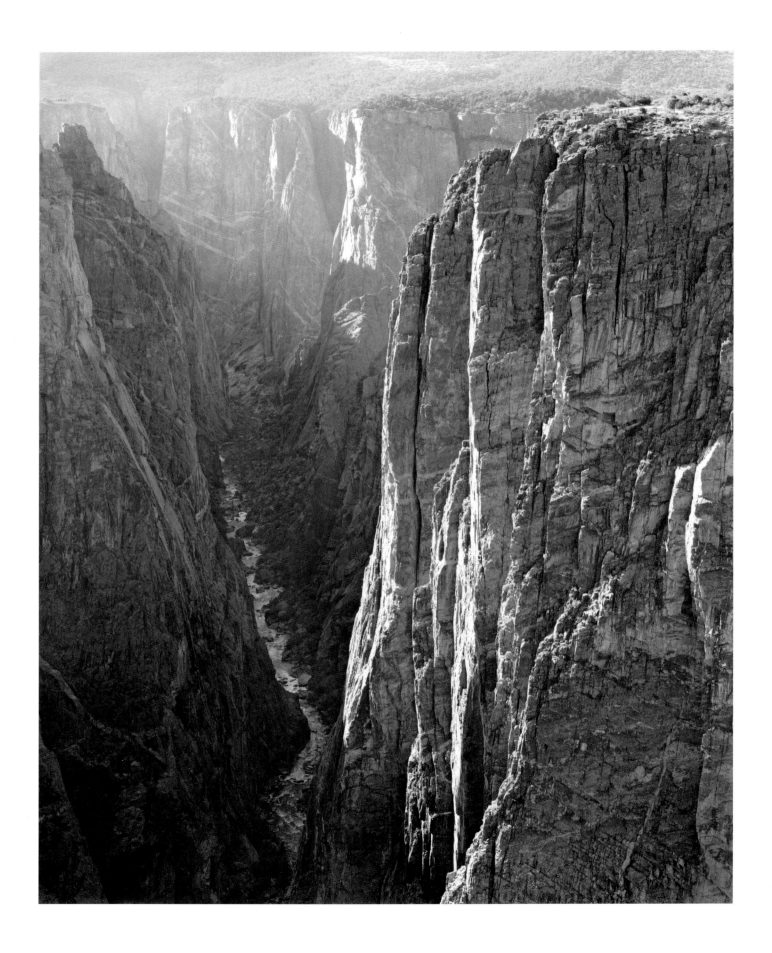

SAGUARO DETAIL, SAGUARO NATIONAL PARK, ARIZONA, 1998

FACING, LONG VIEW, BLACK CANYON OF THE GUNNISON, COLORADO, 1993

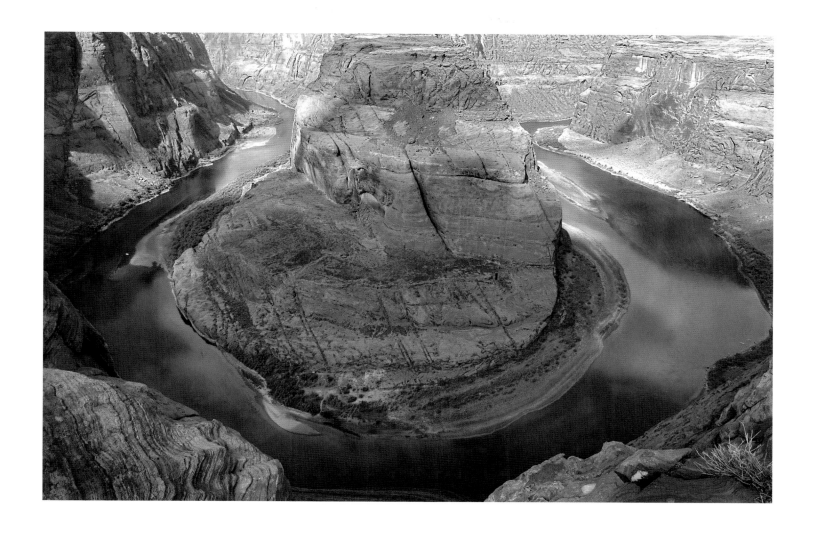

HORSESHOE BEND, COLORADO RIVER NEAR PAGE, ARIZONA, 2004

THIS IS AN OFTEN PHOTOGRAPHED SCENE AND MOST PHOTOGRAPHERS PREFER TO
USE VERY WIDE ANGLE LENSES TO ENCOMPASS AS MUCH OF THE SCENE AS POSSIBLE.
I CONSIDERED THAT OPTION, BUT DECIDED THAT THERE WAS A STATEMENT TO BE
MADE BY ALLOWING THE RIVER AND BUTTE TO PUSH THE LIMITS OF THE FRAME.

FACING, IN CANYON DECHELLY, 1972

In the 1980s and early 1990s, I often worked alone and wrote immediately of my experiences and feelings. I would take a journal when I hiked and often make notes and sketches while waiting for lighting conditions to change. In the company of others, one is less free to write while working, but the value of keeping journals cannot be overstated, and for years I have admonished students to include at least a small spiral notebook in their travel packs. This is not so much for recording technical information, though that is often valuable and necessary, but for recording their experiences.

I keep journals to record the thoughts and feelings that motivated me to make pictures, and to describe in detail the experiences associated with travels and outings. I record who I met along the trails, who was with me as I worked, and discussions we shared. Journals may later form the basis for exhibit labels, or for stories I weave into presentations and workshops. Much of the material in this book relies heavily on journal content.

I tend to do my best work when I'm alone because I'm more comfortable setting my own pace without concern that other people might be waiting for me before moving on. There are occasions, however, when I enjoy working in the company of others and sharing observations. In these instances, I try to avoid making pictures of subjects similar to those the others are photographing, and when we do share subjects, I look for a different perspective or a different light.

When two photographers make photographs of the same subject from the same location, there usually will be significant differences between their final images. This occurs because of the inequality of individual perception and style. Even so, photographers often serendipitously make images so similar to those of others that they risk being accused of imitation.

143

Under potentially dangerous conditions, I prefer to hike with a companion. I would not, for example, climb into the Black Canyon of the Gunnison alone. There are too many places where a hiker or climber can slip and fall. With a heavy pack and tripod an accident can be disastrous.

In Maine several years ago, while on an assignment for the Sierra Club, I fell and broke a leg. I was hiking in the rain on a poorly maintained portion of the Appalachian Trail. Had I been alone, I don't know how I would have been rescued, but I had plenty of company. Supported on the shoulders of two companions, I limped for a half-mile to a point where the trail crossed a forest road and from there a local resident drove me to the nearest hospital.

Landscape photography does not require a person to take significant risks. Many excellent and very well-known images have been captured from roadsides and similarly accessible viewpoints. If the subject is a good one, it matters little where you find it.

One of my most successful images, *Moraine Park at Two A.M.*, was made just a few feet from the steps of the William Allen White Cabin where I lived as artist-in-residence at Rocky Mountain National Park. Curiosity calls me to seek out the places where others are less likely to tread, however, and many of my photographs have been made at the bottom of canyons, in high mountain passes, and along back-country lakes and streams where, in solitude, I often find inspiration.

145

DESERT AFTERNOON, GUADELUPE PEAK, TEXAS, 1981

MORAINE PARK AT 2:00 A.M., ROCKY MOUNTAIN NATIONAL
PARK, COLORADO, SEPTEMBER 16, 1986

OVERLEAF: AT THE DAWES GLACIER, ALASKA, 2002

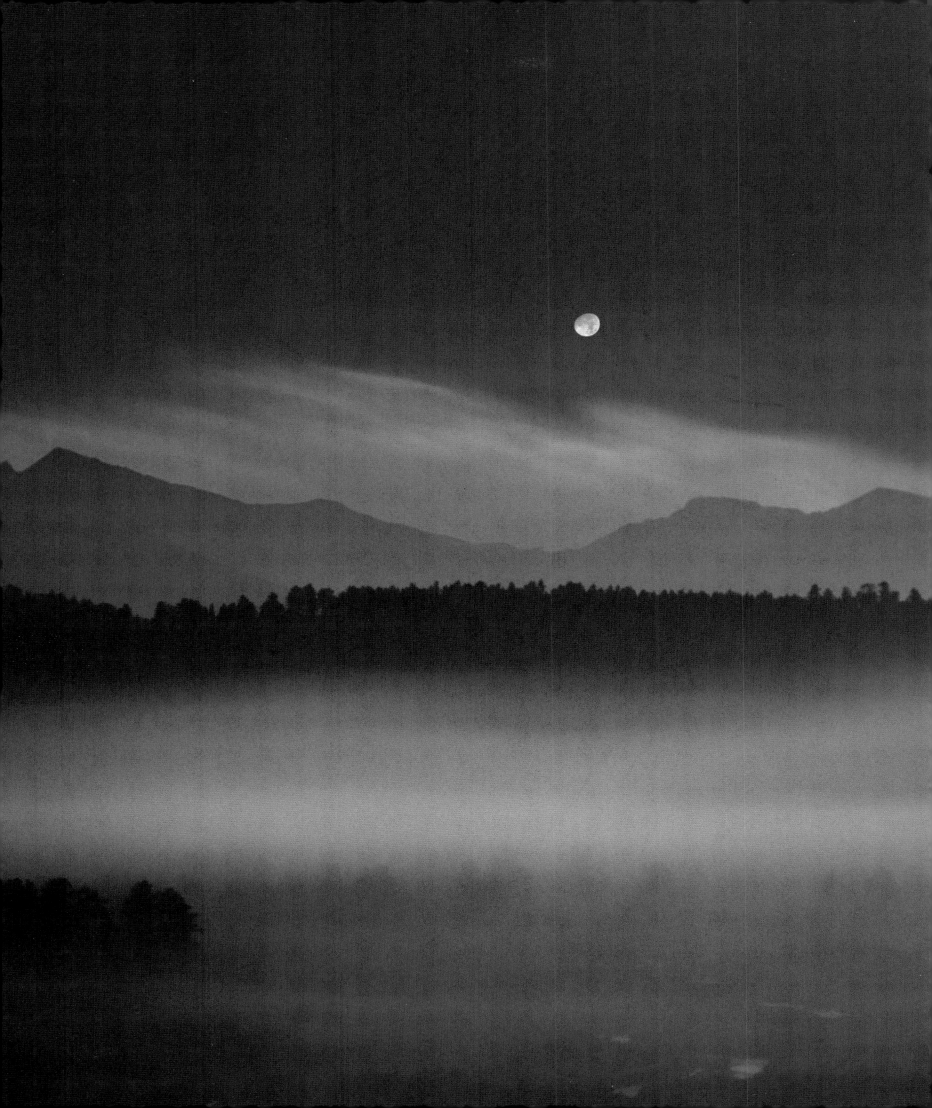

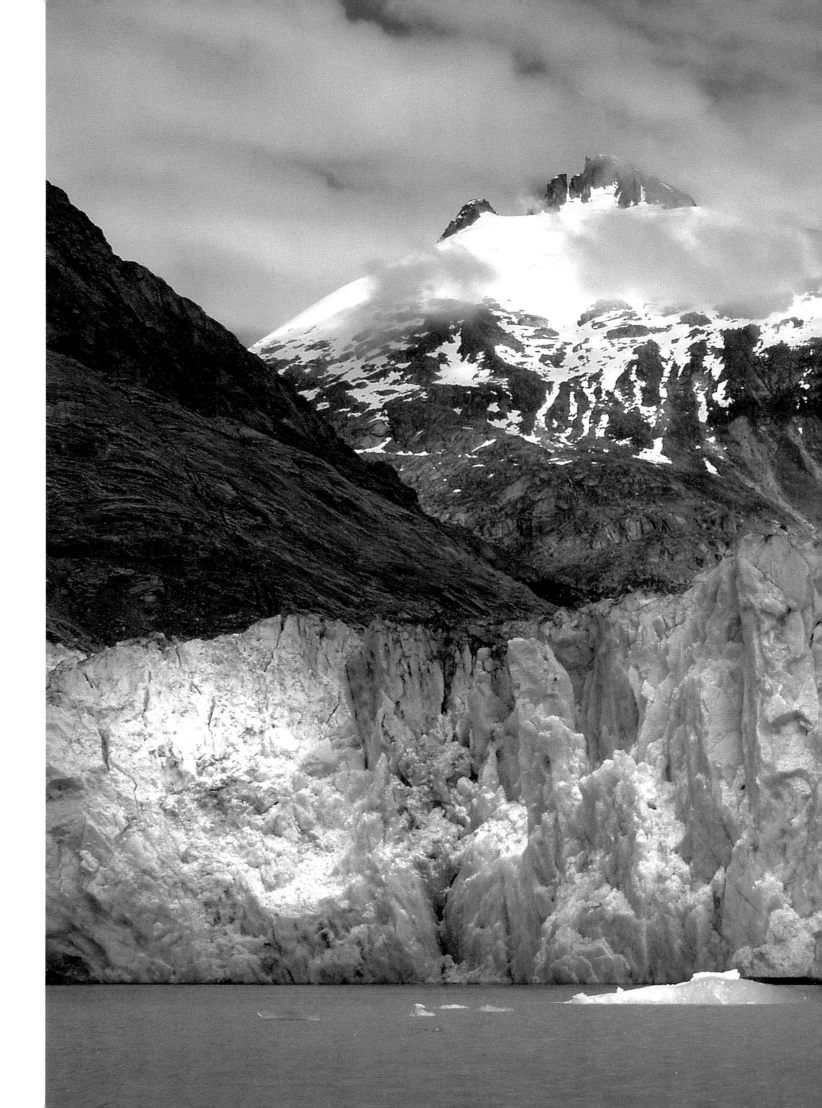

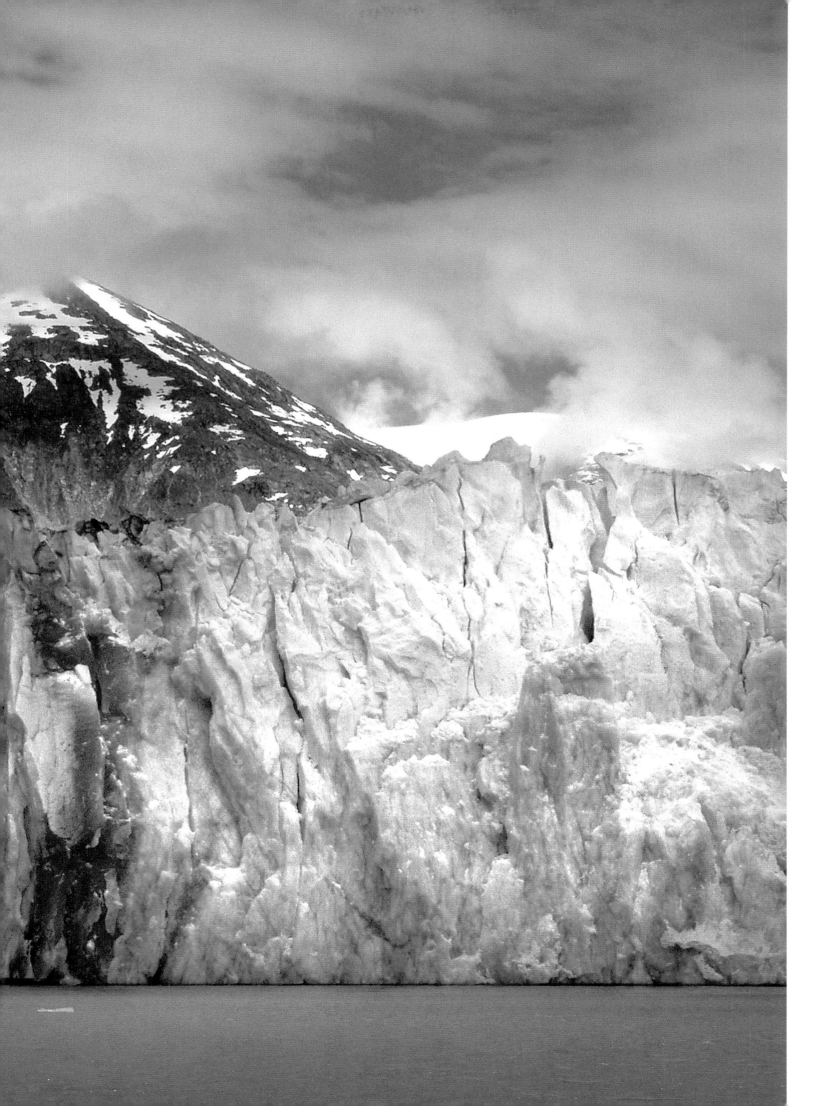

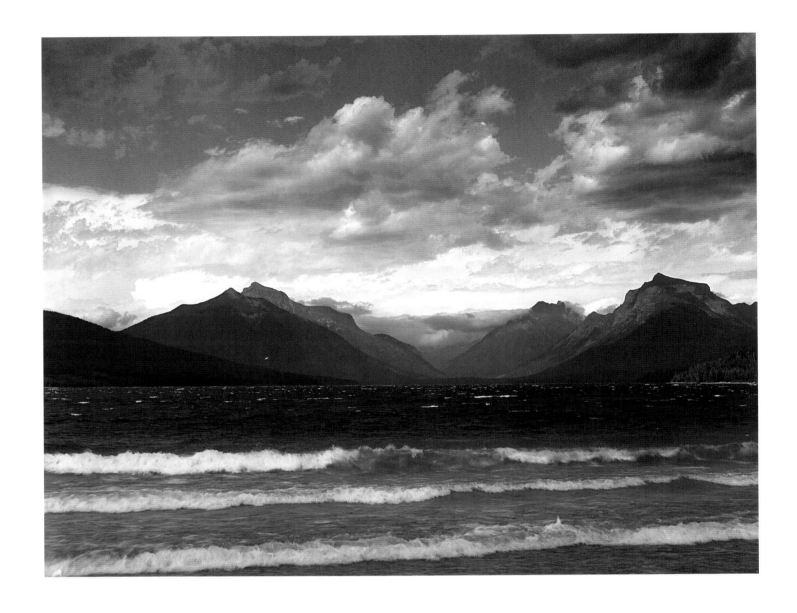

150

LAKE MCDONALD, STORM, GLACIER NATIONAL PARK, MONTANA, 1990

FACING, WHITE BOULDER AT OTTER POINT, ACADIA NATIONAL PARK, MAINE, 1994

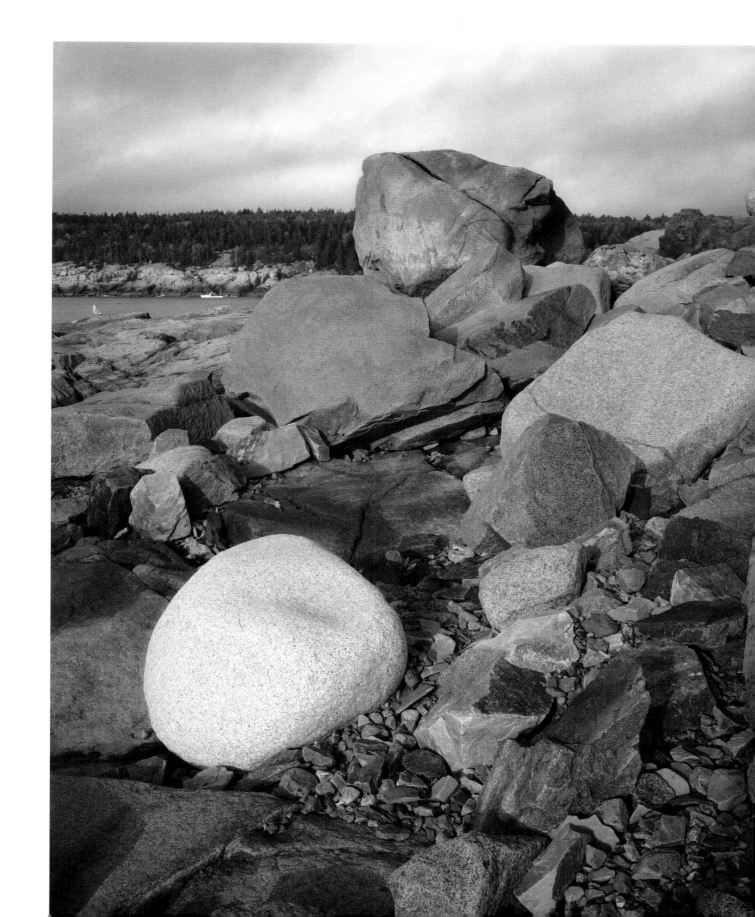

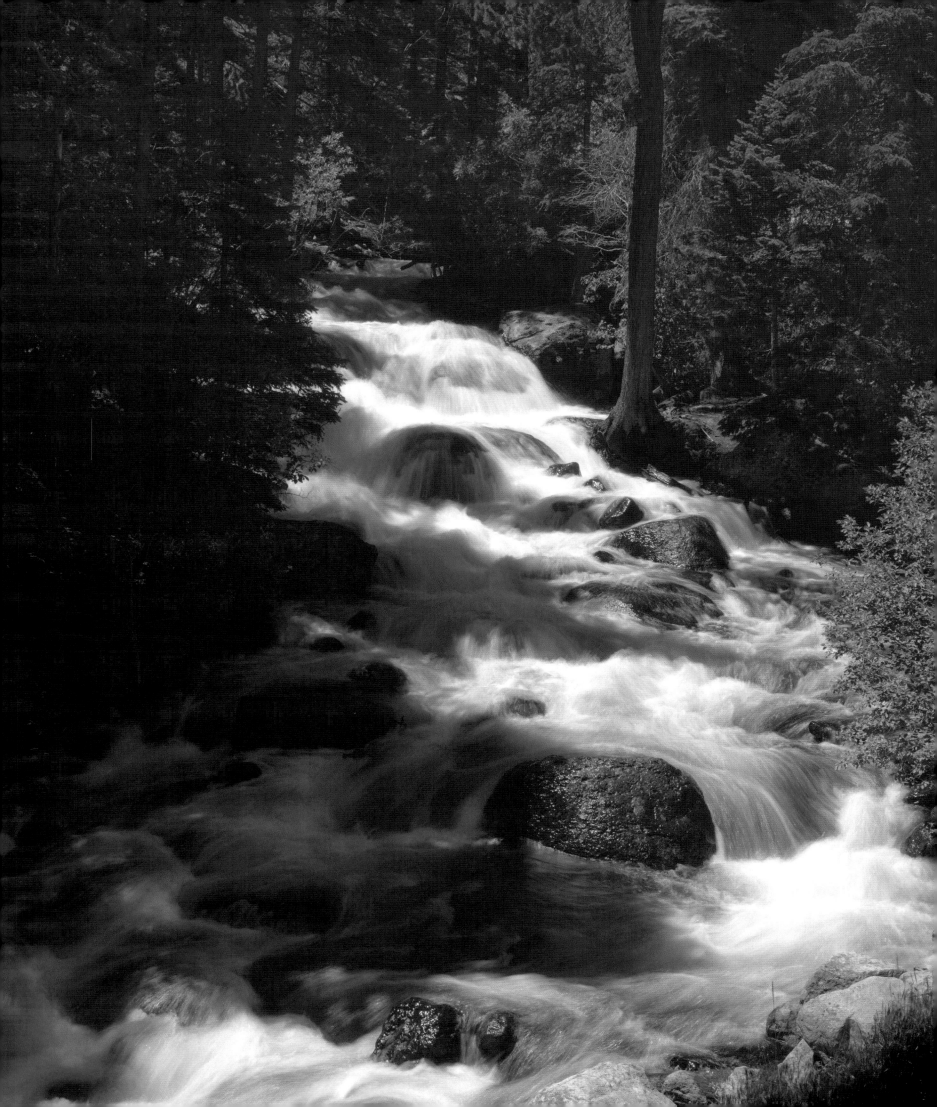

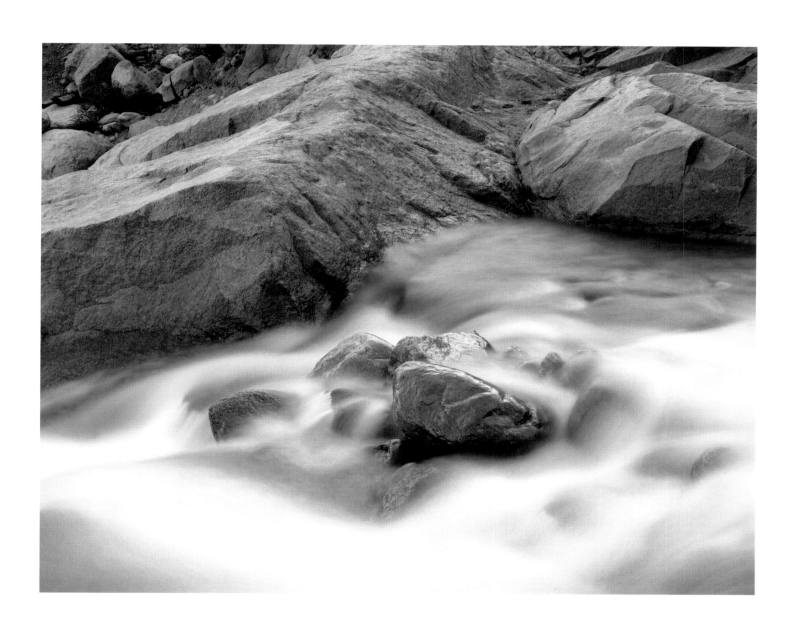

ROCKS AND ROARING RIVER, ROCKY MOUNTAIN NATIONAL PARK, COLORADO, 1999

FACING, GLACIER CREEK CASCADE, ROCKY MOUNTAIN NATIONAL PARK, COLORADO, 1995

REFLECTIONS

LOOKING BACK THROUGH THE YEARS, I realize how my perspective has been altered by age, occupation and family changes. One might think, from what I've written, that I was constantly preoccupied with photography from the time I picked up my first camera, but that is not the reality. Although photography has contributed enormously to making me who I am, there have been periods when the camera had a much smaller place in my life.

In my earlier years, my fascination was with drawing and painting, music and friends. I studied the violin from childhood until I left Nashville to attend the University of Missouri. I loved the instrument, would sometimes practice for five hours at a stretch, and the influence of my teacher, Kenneth Rose,[19] is still evident in my life. My talent as a violinist is not noteworthy, but I still love the instrument.

My admiration for the violin's smooth fingerboard sprang from a dislike of too much structure. It also represented a feeling I still have that if a task is too easy, it probably won't add to one's growth and thus may not be worth doing. I suppose that both these attitudes are in keeping with a selection of the camera as an instrument of self-expression. A love for music and a passion for photography are also akin in mirroring a desire for discipline, harmony, precision and understanding. Whether or not I have been capable of expressing it, my life

156

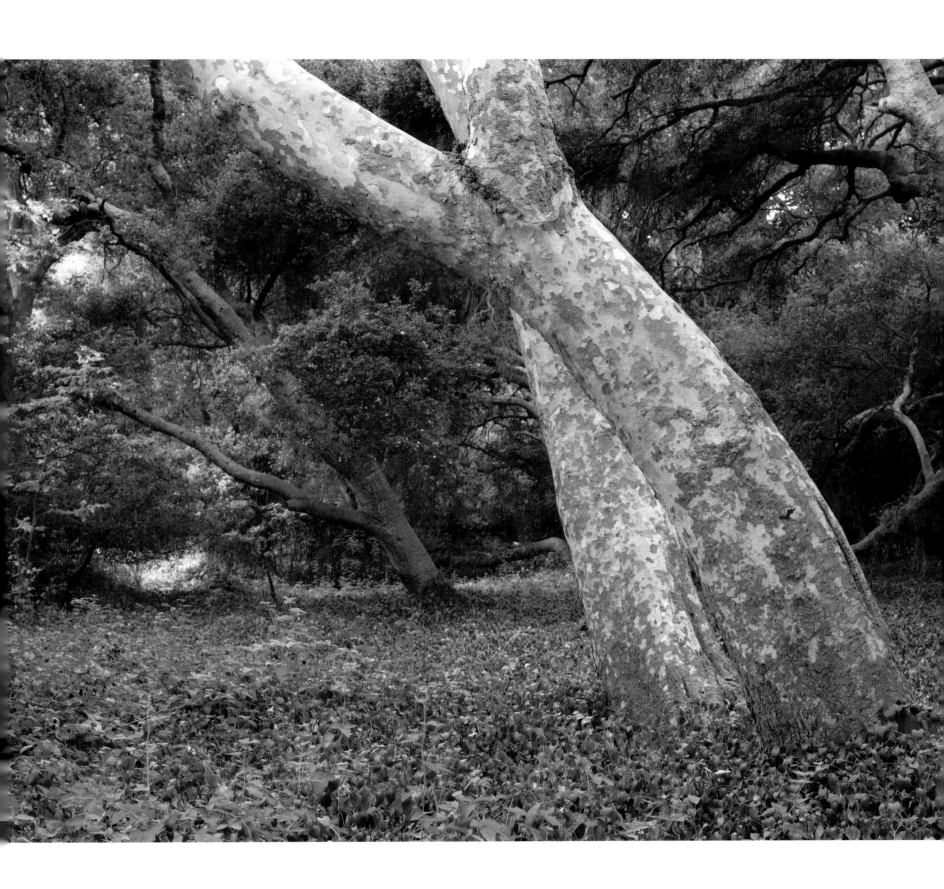

has been a series of internal and sometimes external struggles to find meaning in relationships, perfection in the quality of work, appropriate interpretations that make all the elements of a life seem relevant in so many ways. To me, the effort to achieve beauty, like the effort to understand the true nature of love, is a never ending quest through which all life is elevated.

I grew up in a community where, except for libraries, visits to the studios of local photographers, occasional commercial photo seminars and conversations in the camera store, there was little opportunity to study the history and craft of making images on film. During my high school years, however, I did have an extraordinary mentor. He worked in my father's business and studied, in the 1940s, at the Nashville School of Photography following service in the U. S. Army. We constructed a darkroom in what, as I recall, had been an unused warehouse bathroom, and there he taught me and monitored my progress. His name is Billy Easley and he later became the first African-American photojournalist to work for a major southeastern daily newspaper—the *Nashville Tennessean.*

Billy Easley had a remarkable work ethic and an insatiable thirst for knowledge. He was the only person I ever knew who had the patience and desire to sit down and read the dictionary, which he often did during his lunch hour. Now retired, Billy continues to express interest in a wide range of subjects and is surrounded by evidence of his many accomplishments. We remain close friends.

Though I expressed an interest in photography as a profession while in high school, I was not encouraged. My parents and teachers saw photography as a less than lucrative vocation, and thus somewhat less than honorable. My creativity was, therefore, channeled toward advertising and marketing.

BILLY EASLEY FROM A 2006 VISIT

158

Station around 1:30 in the afternoon. Vance Cotter, the north Rim Ranger was not on duty, so we registered ourselves and quickly headed down the trail to the take-off point for S.O.B. Draw. The entire route descends 1800 feet and the length of the trek is 1¾ miles. The information sheet available at the visitor center says that average time for the descent is 2 hours and for the return — 4 hours.

The trail begins steeply and quickly arrives at a shelf that at first seems unmanageable for a hiker with a backpack as heavy as ours. We found, however, a way down the rock and continued on loose talus down a steep incline, noting our position relative to the rocks of the sides of the draw. The descent was slow and we were extremely cautious. We paid little attention to time.

The way was slippery and frequently we turned to face the rock and lowered ourselves down hand over hand.

I was surprised that there were, in most places, obvious signs of a "trail." Clearly, I had not expected an obvious route. My earlier experiences were with having to constantly make route judgments, taking the path of least resistance. Later, I found that in S.O.B. everyone stays to the right going down, except for a short section at the top of the draw when you must move left and follow that with a scramble to traverse to the right side.

At one point, I came to a rock so steep and slippery that I dare not attempt to climb down it with my pack on. I placed the pack flat on the rock above me and lowered it slowly as I inched my way foothold by

THE 1993 JOURNAL FROM A TRIP TO THE BLACK CANYON OF THE GUNNISON CONTAINS AMPLE NOTES ON THE PLACE AND MY FEELINGS ABOUT IT. AT THIS STAGE I AM INTERESTED IN RECORDING WHY, RATHER THAN HOW, PARTICULAR PICTURES WERE MADE AT A SITE.

159

Once I began working for a living, my interest in photography became more intense. I used my images first in the printing industry and later in my work with a number of advertising agencies, and often gave personal attention to the work of other photographers in projects in which I was involved, always learning as I went along. Personal photography, however, took a back seat to making a living and establishing a reputation as a marketing professional. Though I never stopped making pictures, I was preoccupied with the business of advertising—helping to create images of clients and their products in words and pictures. My recollections of this period are sometimes uncomfortable and I am extremely thankful that I had loving family and caring friends who showed patience and understanding during the times when I allowed my work to take precedence over virtually all else.

I remember the exact moment when this began to change, but it required time and effort to develop a balanced set of priorities and values.

Shortly after moving to Tulsa, Oklahoma, in 1971, I left the advertising agency business to work as a freelance writer and photographer. It wasn't long before the demand for my photography steered me in the direction that produced my greatest satisfaction and emotional stability. I created a successful commercial photography studio and from that time on rarely looked back.

EVENING IN THE FOREST, GLACIER NATIONAL PARK, 1990

OVERLEAF: UPPER MACDONALD CREEK, GLACIER NATIONAL PARK, 1990

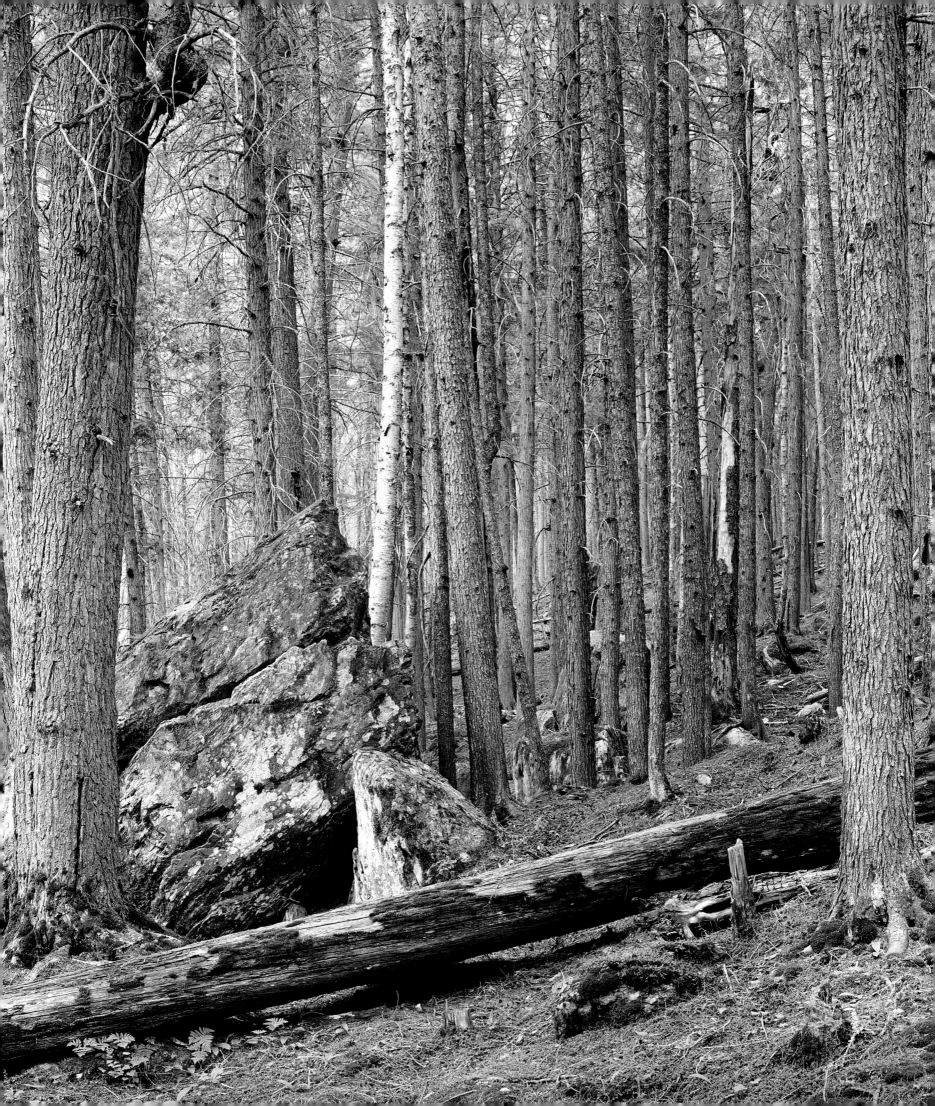

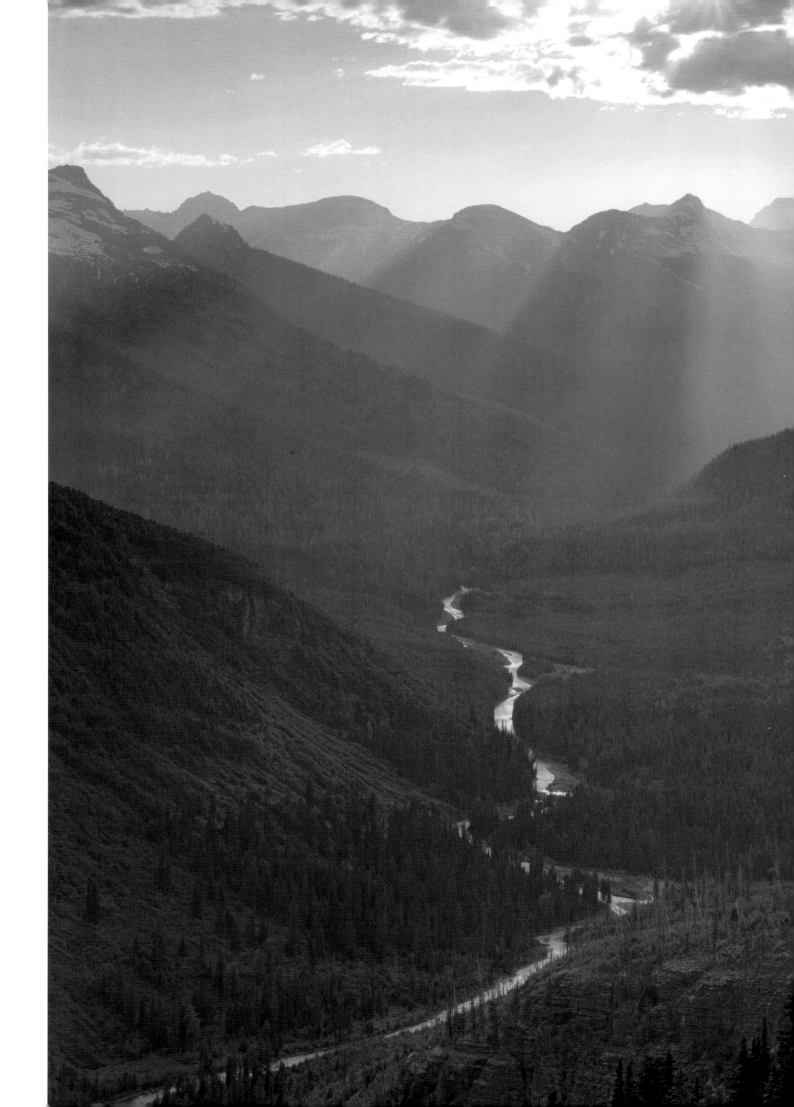

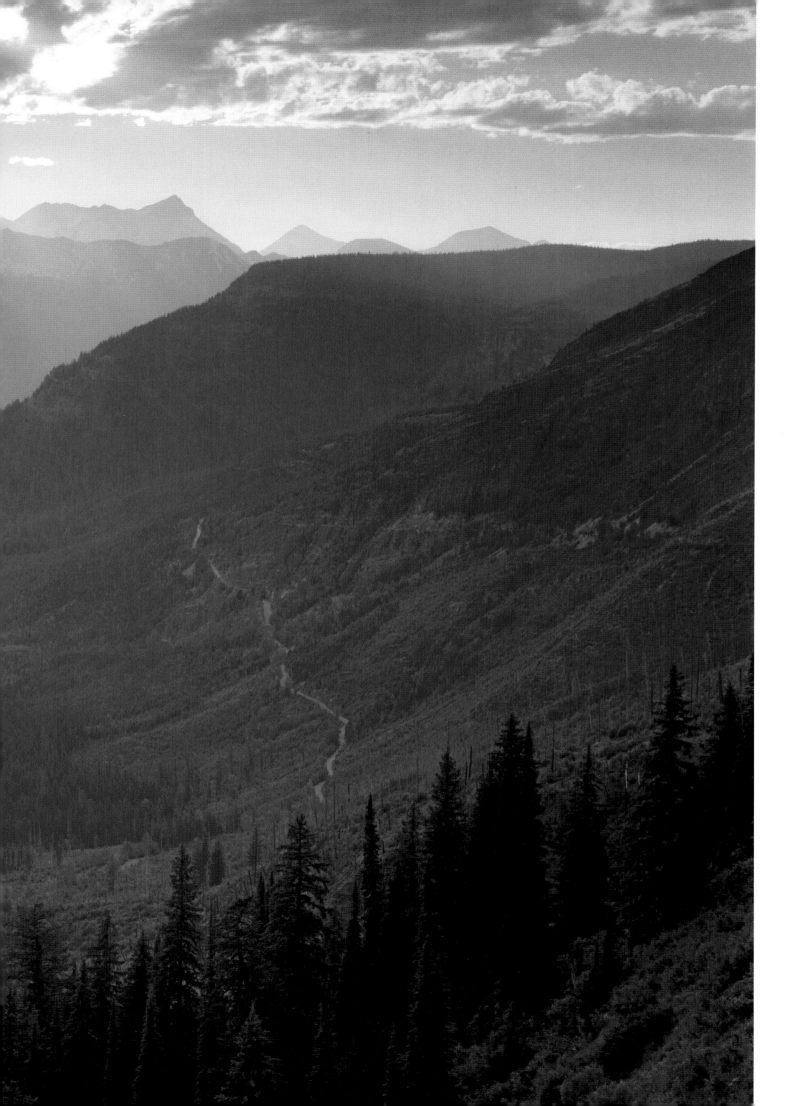

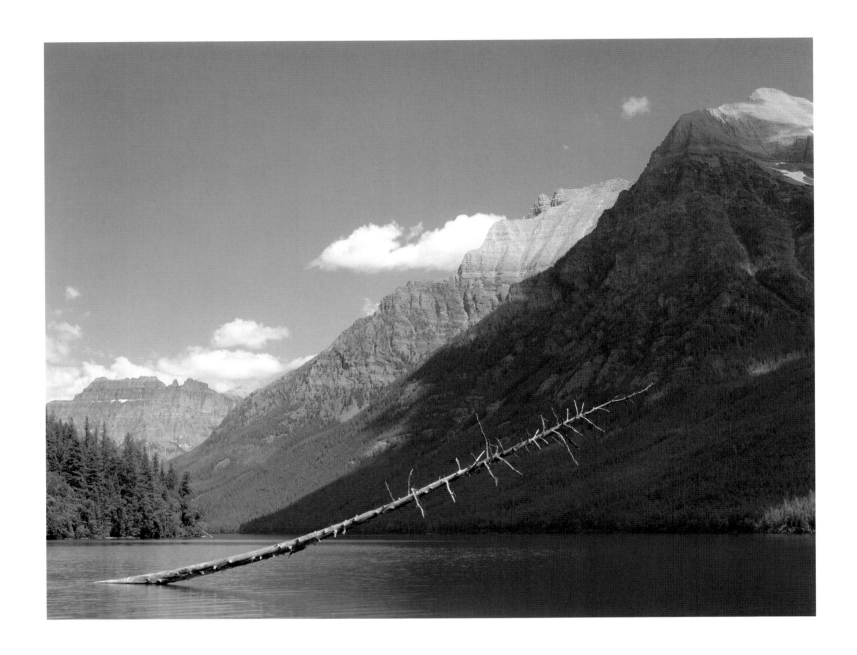

164

In the mid 1980s, I made a decision to devote a larger portion of my time to personal photography and publicly announced my intentions when interviewed for a newspaper article that appeared in the *Tulsa Tribune* on May 28, 1986. By that time I already had served twice as a National Park artist-in-residence and my commercial assignments had crisscrossed the country from Alaska to Florida and southern California to Maine. I had made photographs from the crown block of oil rigs, from the open cockpits of helicopters, in coal mines and factories and board rooms and I had created elaborate studio illustrations. We were discussing my work as a commercial photographer, but I found myself saying, "It gets to the point where you get so comfortable you forget who you are and what you're supposed to be doing. . . . I'm never again going to ignore my personal work."

Though I've won my share of awards, I generally don't display them. Somewhere in files and corrugated cardboard boxes, my children may someday find some certificates, but only two awards are displayed in my office. They are gold awards from the Art Directors Clubs of Tulsa and Kansas City, given to the two editions of the book *Tulsa Art Deco*.

In 1995, had you asked me what I would be doing today, I would have told you that I would be making pictures, but not in the manner in which I now make them. I would have told you that I would still be shooting images with my large format cameras, processing film and making prints in my darkroom, and defending the purity of the straight image and the silver print. I would have told you that the technology of digital photography was fascinating, and that while I would like to work with it to some extent, I planned to continue relying on traditional methods and technology.

WINTER ON GLACIER CREEK,
ROCKY MOUNTAIN NATIONAL PARK,
COLORADO, 1987

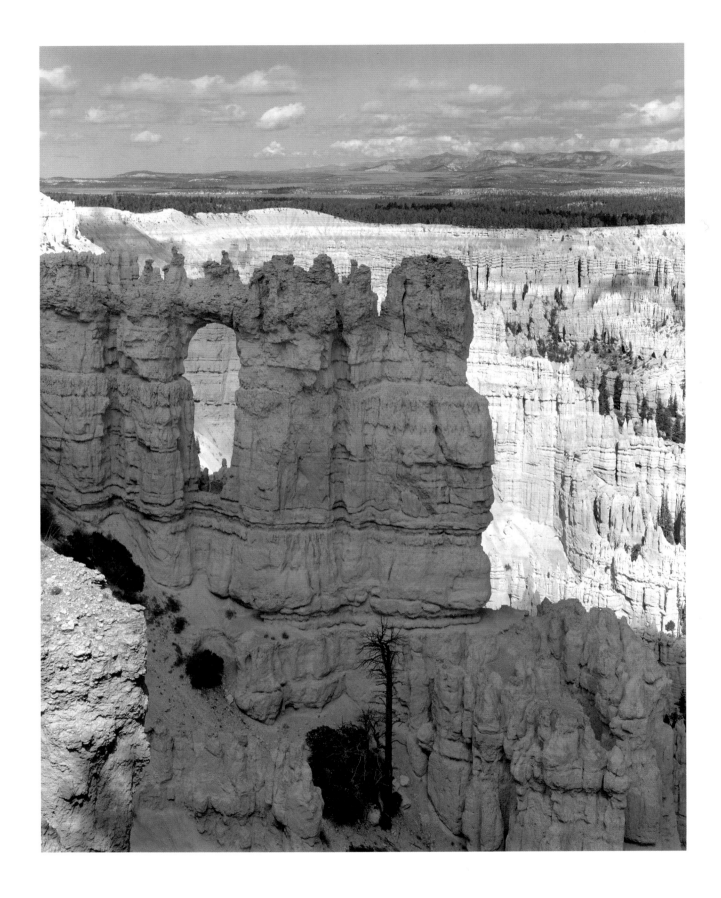

166

SHADOW ON THE WINDOW, BRYCE CANYON NATIONAL PARK, UTAH, 1988

What will I be doing years from now? Making pictures. And no doubt embracing new technology about which we can now only speculate. What I will be doing tomorrow will be better than what I can do today, and I will continue to be more excited than ever by photography, its challenges and its potential applications to creative art. There will be more landscapes to explore, and I will try to find more ways to interpret them.

NOTES

1 Film with limited sensitivity, typically less sensitive to red light and therefore able to be developed under a red safelight which provided enough illumination to permit a person to see the film and the implements of the darkroom, but not enough light to damage the film through overexposure.

2 The Argus C3 was a popular 35mm camera produced in the U.S. from 1939 through 1958 and commonly called "The Brick" because of its shape and heavy construction. When Henry Meyer died in 1985, his pre-WWII Argus was given to me by my aunt, Sara Meyer. It is still operable and a treasured possession.

3 A film sensitive to all the colors of light, requiring development in total darkness.

4 Commonly referred to as print film as opposed to transparency or slide film.

5 Source: Wilhelm Imaging Research, Inc.

6 Helene Inge Connell, b. 7/31/1907, d. 6/21/1990, taught art in Nashville, Tennessee from 1937 through 1970. She was the sister of playwright William Inge.

7 The Century Graphic, a "press type" camera introduced by Graflex, Inc. in 1949, using 2 ¼" x 3 ¼" sheet film.

8 Formerly Cibachrome

10 Ink-jet printing uses dye-based or pigmented inks. Each has advantages. Currently, dye-based inks tend to produce more vivid color; pigmented inks last longer.

11 The word photography is derived from Greek roots meaning writing with light.

12 Fritz Perls (1893–1970) developed and popularized Gestalt therapy. Trained as a psychoanalyst in Berlin, then Austria, he moved to South Africa, establishing a training institute for psychoanalysis there before developing his unique theoretical approach. His work emphasized a phenomenological and subjective approach to therapy. A goal of his work was to move people into owning their experiences and developing into a healthy gestalt (or whole).

13 From 1958 to 1973, I pursued a career in advertising, marketing and public relations.

14 Ernst Haas (1921–1986) is often called the "father of color photography."

15 Landscapes often are seen as creations of nature itself and less the creations of the artist.

16 Aldo Leopold (1887–1948) was often called the founding father of wildlife ecology. Quoted from *Round River,* Oxford University Press, New York City, 1966. Leopold's cornerstone book *Game Management* (1933) defined the fundamental skills and techniques for managing and restoring wildlife populations. This landmark work created a new science that intertwined forestry, agriculture, biology, zoology, ecology, education and communication.

17 William Allen White (1868–1944) journalist, editor of the *Emporia Gazette* (Emporia, Kansas), was twice recipient of the Pulitzer Prize.

18 Aldo Leopold (1887–1948). From *A Sand County Almanac,* Oxford University Press, 1966.

19 Kenneth Daniel Rose (1888–1960) joined the faculty of the Ward-Belmont Conservatory of Music in Nashville in 1918, and headed its violin department from 1918 to 1952. He worked under the tutelage of Suky in Prague, Arthur Hartmann in Paris, George Lehmann in Berlin, and Leopold Auer in Chicago. In Indianapolis, Rose served with the Germanhouse Orchestra and was concertmaster of the Indianapolis Symphony. Later he was a soloist, guest conductor, and concertmaster with the Nashville Symphony. He also is known for the extraordinary sheet music collection he donated to the Tennessee State Library and Archives in 1956.

PHOTO BY BILL STANDERFER, 2006

Born in Nashville, Tennessee in 1936, David Halpern acquired an early passion for the American landscape while traveling with his family through the West in 1952. This fascination reached its lasting intensity in the early 1970s, when Halpern moved to Tulsa, Oklahoma and left his career in advertising and marketing to begin a new life as a photographer and writer. Since then, he has exhibited his work regularly in galleries and museums across the nation and has lectured and taught photography in both college classrooms and field seminars. He has served eleven times as a national park artist-in-residence, and his photographs are in numerous public and private collections, including those of the National Park Service and the Philbrook Museum of Art in Tulsa.

Though his primary interest is the natural environment, Halpern is also known for his architectural photography, and his book credits include two award-winning editions of *Tulsa Art Deco.*

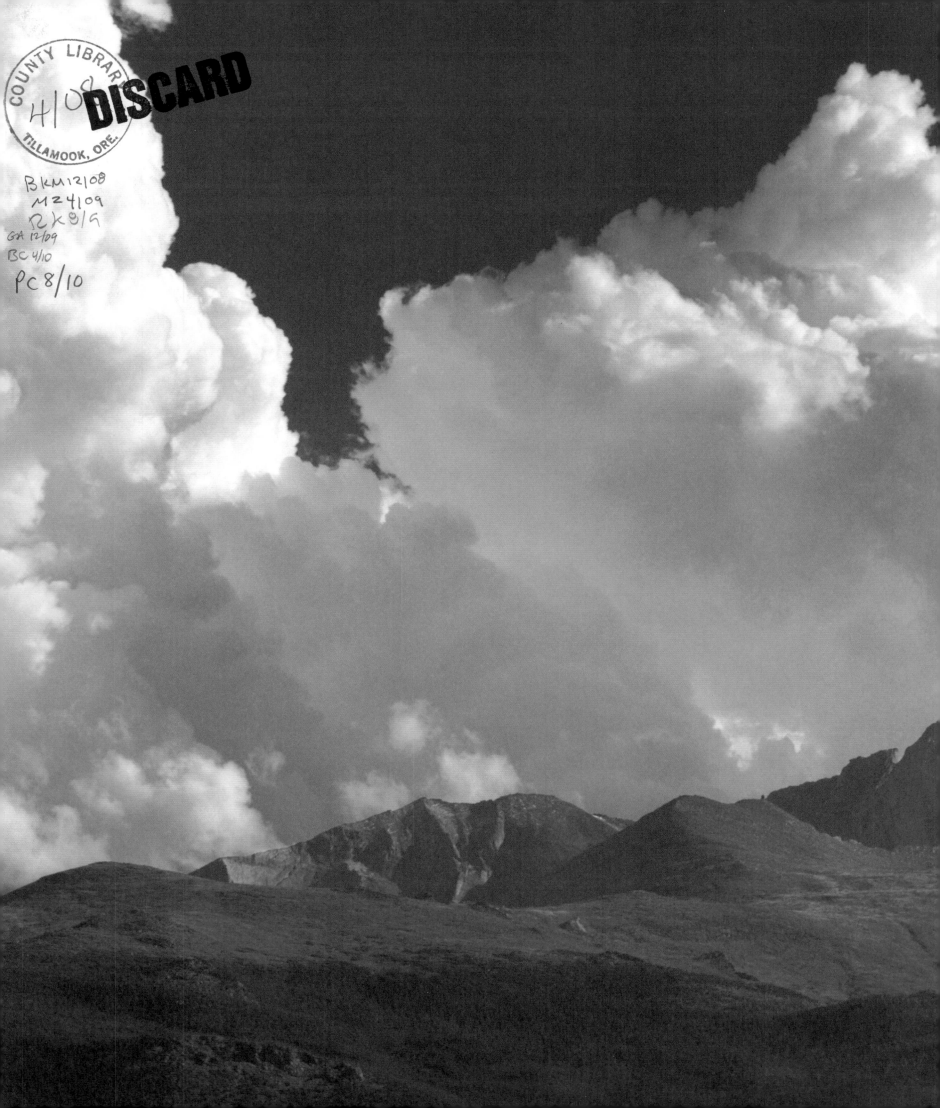